RAJASTHAN

RAJASTHAN
India's enchanted land

Introduction and 80 color photographs by

RAGHUBIR SINGH

Foreword by Satyajit Ray

THAMES AND HUDSON

To Anne

Photographs copyright © 1981 Raghubir Singh
Introduction © 1981 Raghubir Singh
Foreword © 1981 Satyajit Ray
First published in the USA in 1981 by Thames and Hudson, Inc.,
500 Fifth Avenue, New York, New York 10110

Library of Congress Catalog Card Number 80-52093

Printed and bound in Italy

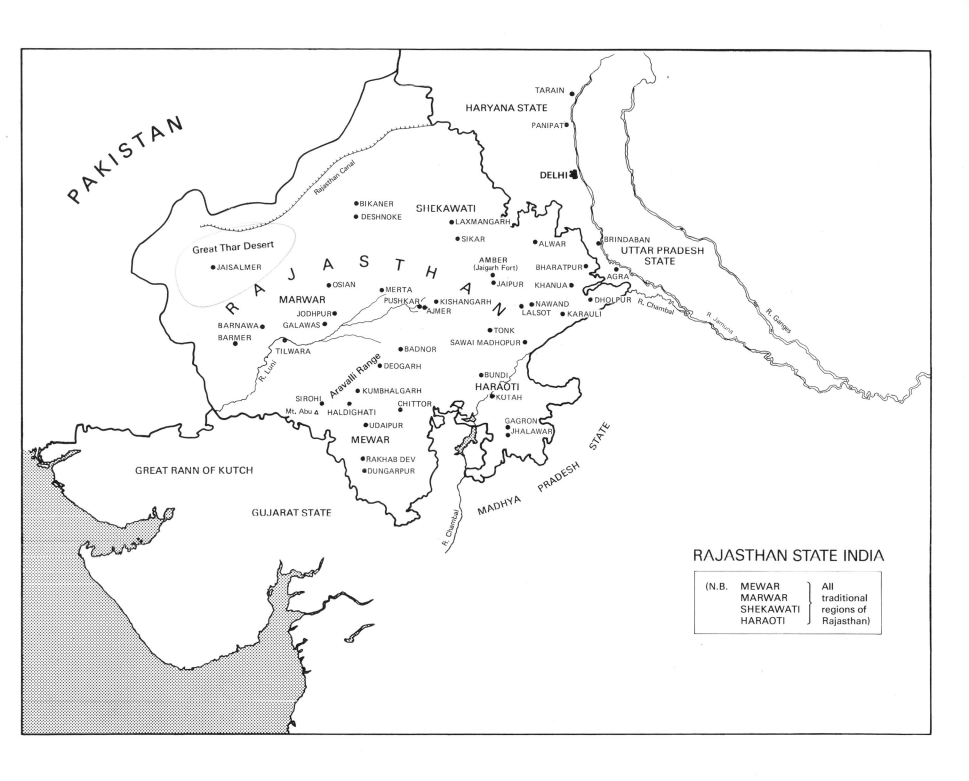

Acknowledgments

I would like to thank the following persons for their encouragement and kindness in the making of this book and during my travels in Rajasthan : Satyajit Ray, Komal Kothari, Thakur Bhopal Singh, Raj Rana Hari Singh, Rawat Nahar Singh, M. K. Brijraj Singh, Dr Karni Singh of Bikaner, Thakur Raghuraj Singh, Maharaja and Maharani of Kotah, Maharaja of Jhalawar, Narendra Singh Bhati, Jai Singh, Shantanu Kumar, Miss Sudha Rajhans, Anand Bordia, Anil Vaish, Krishna Kumar Agarwal, Narpad Singh, Kumar Sangram Singh, William Gedney, Stuart Cary Welch, and R. P. Gupta.

The excerpts from Jawaharlal Nehru's speech before the first Constituent Assembly and from the *Glimpses of World History* are used with the kind courtesy of Shrimati Indira Gandhi.

Foreword

When we were very young, a Bengali book we were much taken with was called *Rajkahini*, or Princely Tales. The tales were about real kings and real princes; but so filled were they with the stuff of romance and chivalry that they didn't seem real. We read of a land of desert and forest and mountain fastnesses; of marble palaces rising out of lakes like gem-studded lotuses; of brave Hindu warriors on faithful, fearless steeds charging into battle against invaders; and of their womenfolk who threw themselves into the flames rather than be snatched away as prizes by alien conquerors.

Rajasthan, whence these tales emerged, was then known as Rajputana. I still prefer the four syllables to the three; they seemed magically to evoke a faraway, fairy-tale land. We looked at the map of India, and it only confirmed this feeling of remoteness. If Sind and Gujarat on the western tip formed the upper and lower jaws of the legless lion that held Kutch between its teeth, then Rajputana was its cheek, and Bengal, set well towards the eastern edge, was its slender waist. The Bengal we knew then was mostly flat and green and wet, while the Rajputana we read about was rugged and sunbaked and beautiful. Bengal had all the big rivers, but didn't have the Thar desert; and without a desert you couldn't have simoons and mirages and camel caravans trudging their way across endless sandy wastes. Also, Bengal had nothing in its past to compare with the procession of brave kings and stirring battles that marked the thousand-year history of Rajasthan. What was Plassey compared with Haldighati? And where were our heroes to set beside Prithviraj and Rana Pratap and Jai Singh? . . .

I doubt if I'd have ever got to know Rajasthan well if I hadn't decided to become a film maker. As a student of painting in Santiniketan, I had already discovered the exquisite world of Rajput miniatures, and realized that it wasn't just the martial arts that the Rajputs excelled in. And, of course, even as a child I knew some of the beautiful devotional songs of Mira, the Queen of Chittor who shed her finery to become a lifelong devotee of Krishna. Indeed, the lure of the enchanted land had grown over the years, and as soon as I found an opportunity, I decided to go filming in Rajasthan.

Although filming brings one closer to a place and its people – and I've been to Rajasthan six times – proximity has done nothing to dispel the aura that the place once held for me. If anything, by making me aware of its richness and diversity, it has entrenched itself even more deeply in my imagination.

Setting off from Jaipur by train and heading west, one notices how the land dips and rises by turns, how the wheatfields give way to scrubland, and the lush green to tawny ruggedness. At every halt in the journey, one observes the people. A very special breed, the men, proud in their whiskers and their turbans and their tunics flared at the waist. As one moves on westward, one watches the whiskers growing more luxurious, the turbans bigger and redder, the tunics shorter and more flamboyantly flared. The impression of strangeness is heightened by the delighted discovery, early on, that the ubiquitous and prosaic crows and sparrows of Bengal have all but disappeared, and their places taken by stately peacocks and fleet-winged green parakeets.

The contrasts are enough to take one's breath away. In a country where for miles one sees nothing but sand and rock and bramble and camels, I have seen a seven-mile stretch of marshland where thousands of birds from across the continents come and make their seasonal homes on treetops and tiny islets, filling the air with their calls and spattering the landscape with colour. I have seen fortresses perched on hill tops, fortresses rising out of barren plains, fortresses in forests, fortresses in the middle of cities, and fortresses nestling in the lap of mountains. I have seen palaces and *havelis* of marble and stone, airy ones and massive ones, all with exquisite carvings on them; and I have seen the ruins of a village of stone dwellings which go back a thousand years. In the museums I have seen swords and shields and lances the warrior kings fought with, some studded with jewels, all impeccably crafted; and I have seen paintings on the walls of present-day dwellings where the colours and the brushwork strike one dumb by their sweep and gaiety. And, of course, the women – and this goes for the whole of Rajasthan – women stepping straight out of the miniatures, decked out in brilliant reds and greens and yellows, disporting themselves with a grace that

would rouse a queen's envy, and striking a joyous note in the drabbest of surroundings.

And music, too. The strangely beautiful bowed instrument with a tinkling bell, the *ravanhatta*, that the man in the blue tunic played all along the way as we rode on a caparisoned elephant up the ramp to the Amber Palace. Then, at the end of a day's hard work, the limpid melody on the double-flute that came floating over the horde of squatting camels we'd used earlier for our shooting, drawing us irresistibly to the dreamy-eyed Moslem who played it, and who regaled us with many more such melodies. I shan't forget, either, the old, bearded Moslem in Jaisalmer, desperately poor, who sang lovingly filigreed classical ragas, sitting in our hotel room, while he ran a bow vigorously across a kind of *sarengi* I'd never seen before . . .

It is no surprise that a segment of India which has inspired poets and painters, novelists and playwrights (Bengal alone provides many examples) should also inspire the photographer. More so because there are few places as photogenic as Rajasthan. Raghubir Singh himself belongs to Rajasthan, and hence knows its soil and its seasons. This might well have worked against him, depriving him of the objectivity and freshness of viewpoint that an outsider can bring to bear on a place and its people. One notes with delight that this has not happened in the present case. Raghubir's view of Rajasthan in all its varied aspects, from the most mundane to the most splendorous, reveals a mixture of wonder, admiration and probing curiosity which, added to his skill and experience as a craftsman, gives this album of photographs a very special distinction.

Satyajit Ray

Introduction

I was born in Jaipur, the capital of Rajasthan. A rambling house within the walled city was home for our large, joint family. This *haveli* was constructed around three courtyards, two in front for the men and another at the back for the women. In the central enclosure were stables for horses and places for parking carriages and cars. Cows and buffaloes were tethered in the open. A lemon tree in the centre was dwarfed by a flame-of-the-forest which burst into bloom in March, a sure sign of the changing weather. On the hot summer days of my childhood, my brothers and I splashed about in a small pool. In the cool mornings and evenings, my father sat on a cane chair, receiving visitors or poring over papers connected with our landholdings.

On a hill facing our house, the ramparts of Nahargarh twist and turn to join those of Jaigarh, six miles away. These enchanting forts were packed with mystery, for we had been told the fabulous wealth of the Maharaja of Jaipur was kept there, guarded by fierce Mina tribesmen. In our *haveli*, there was a small armoury where daggers, swords, spears and rifles were stored, along with ornaments of silver for the horses. Above them hung a lithograph of Durga, the warrior goddess, who was shown triumphantly riding a tiger. During the Navratra festival these arms were brought to the adjacent temple. We would gather there to watch my father pray before the sacred fire and the image of the *Mataji*, the great goddess, as two priests chanted Sanskrit hymns. For us the ceremony reached its climax when my father unsheathed the swords and the daggers, touching them to the flame. This simple action excited us immensely.

The martial trappings, the ceremonies, and the stories my mother and father told provided us with a treasure around which we built our childhood games. In our fantasies we believed ourselves to be part of a fairy-tale world of fearless warriors on galloping horses and battling elephants. When we played with toy cars and airplanes, the passengers were always princes, especially the Maharaja of Jaipur who led his team to victory on the polo fields of France and England.

In the women's section of the *haveli*, where my mother lived, she had to wear brocade, heavy gold bangles and armlets every time she appeared before my

grandmother. Only a few male members of the family could enter the *zenana*. On occasions when my mother visited a relative or went to a temple, the windows of the carriage were draped with heavy curtains.

My mother came from a village close to Chittor and we placed the rulers of Mewar, the renowned region of Rajasthan, above all the rest. She had her favourite story. At the battle of Haldighati, where Rana Pratap fought the might of the Grand Mogul Akbar, both he and his horse, Chetak, were wounded. One of my mother's direct ancestors snatched the crimson standard from him and drew away the force of the Mogul attack, allowing Pratap to escape and begin his long and lonely guerilla warfare.

My father would pull out with pride a long matchlock and point to an inscription on it which suggested it had been used by the Emperor Akbar during the siege of Chittor. My grandfather had acquired the weapon when he commanded the Jaipur State Forces.

We were told my grandfather had a violent temper. One day a woman was spotted peeping out of one of the tiny windows of the women's quarters, opening onto the middle courtyard and the men's world. On hearing about it my grandfather flew into a rage and ordered the windows to be cemented. Only my father's tactful handling of the situation stopped the threat from being carried out. Grandfather's word was usually law.

He had travelled to England in 1910, accompanying the Maharaja for the coronation of George V. The ship on which they went and the house occupied by the Maharaja in London were thoroughly washed, as they were considered tainted by the Europeans. Drinking-water from the Ganges, for the Prince's use, was carried in huge silver urns. Among the purchases my grandfather made on this trip were high velocity guns for hunting from the backs of elephants. Just before he died in 1943, at the age of eighty, when I was six months old, he claimed his eyesight was still good enough to shoot a tiger at a hundred yards.

My father inherited my grandfather's land. As a young man, he had the Rajput passion for pigsticking and shooting game birds. At his club over

Scotch and bridge, he fraternized with the polo-playing Maharaja, the British Resident and others. But after 1950, when land reforms were introduced, he was continuously engaged in litigation to hold onto his lands scattered in different parts of the old Jaipur State. Finally, the Government took over most of them, compensating him with cash bonds. When he died seven years later, my father's world had radically altered. Even though he tried his best, I suspect he was not fully reconciled to the new order. His death, for us six brothers and one sister, was the passing of an age.

The horses were sold off. The carriages and weapons began gathering dust. The many servants we had were reduced to a few. The scribes, who once sat crosslegged poring over accounts, disappeared. Soon our joint family broke up. My elder brothers, now married, divided the house into apartments and furnished them in the western style.

We began cycling to school, when I was in my early teens, and staying for games and movies. There, for the first time, I came into contact with the outside world, and made friends with schoolmates of other communities.

In the meanwhile, my mother retired into the life of an orthodox Hindu widow, no longer running our home. Wearing white or grey clothing, eating only certain vegetarian foods, fasting frequently, she set her mind on making pilgrimages to the holy places she cherished. Later, over a period of five years, a series of tragic deaths cast a gloom over our house. My eldest brother, who farmed, died from malignant malaria; his young son from bad kidneys. Another brother, who resigned from the Army, suffered a fatal heart attack, and a third died in an accident. As these were untimely deaths, we erected a small shrine in our front courtyard for the souls of the departed. There, every day, as dusk envelops our house, my mother prays and lights an oil lamp.

For Rajput women, the modest flame of an oil lamp, or the flames in which the women of Chittor flung themselves to save their honour when their men galloped in vain against the Moguls, both symbolize courage and devotion. In the history of India, the story of the Rajputs is a roaring fire.

I was born a Rajput. Rajasthan was our home. Among Rajasthan's 22,000,000 people my community is not the largest but it has historically been the most predominant and powerful. 'Our ancestry goes back to Rama,' I remember my mother telling me. It is also traced to the sun, the moon and the sacred fire. These are the symbols of the ancient clans formed by the warrior heroes of the two great epic poems, the *Ramayana* and the *Mahabharata*. It was after these clans were reduced through warfare and mixed with groups of immigrants that the Rajput race was born.

The Rajputs spread their might over most of North India, until the first Muslim invasions. In the winter of 1190–91, Muhammad Ghauri marched through the plains of the Punjab to Tarain. There, Prithviraj, the daring and chivalrous hero of the Rajputs, defeated the invader with an army of 200,000 horses and 3,000 elephants. Ghauri, severely wounded, escaped but returned the next year to avenge himself. Using superior tactics, he defeated and captured Prithviraj and put him to death. This battle was the beginning of the Muslim domination of North India, where a succession of Turkish and Afghan kings ruled till the first half of the fifteenth century.

At the break-up of the Turko–Afghan Empire, the Rajputs once again forged a formidable kingdom. Rana Kumbha, the monarch of Mewar, emerged as one of the greatest rulers of India. Of the eighty-four forts of this hilly land, thirty-two were built by Kumbha, including the strategic Kumbhalgarh. He was not only a brilliant military tactician but also a poet, a musician, a writer and a patron of the arts. In 1469, after ruling for half a century, he was murdered by his son.

Mewar regained its glory when Rana Sanga, a grandson of Kumbha, ascended the throne. A hero of a hundred battles, bearing eighty wounds on his body, and though handicapped by a crippled leg and a blind eye, he organized the military might of Mewar. He was poised to establish supremacy over the whole of North India when Zahir-ud-din Muhammad Babur arrived on the scene.

In 1527, Rana Sanga, leading an army of 80,000 horses and 500 elephants, advanced to meet the descendant of Genghis Khan and Tamerlane. He struck

terror in the Mogul force. But Babur was undismayed: he broke his drinking cups, vowed never to drink again, and gave a stirring speech to his men: 'The most high God has been propitious to us, and has now placed us in such a crisis, that if we fall in the field we die the death of martyrs; if we survive, we rise victorious, the avengers of the cause of God. Let us then, with one accord, swear on God's holy word, that none of us will even think of turning his face from this warfare, nor desert from the battle and slaughter that ensues, till his soul is separated from his body.'* The two armies met at Khanua, west of Agra. The Rajputs fought fiercely but Babur's superior strategy and his cannon won the battle. Rana Sanga was wounded and escaped, but died before he could recoup his losses. This decisive victory over the Rajputs set the stage for the Mogul conquest of India.

Under Babur's grandson, the great Akbar, the Mogul Empire reached its greatest heights. Akbar conquered large parts of India and united it politically. With his liberal and compassionate outlook, he won over all the Rajputs, except Rana Pratap of Mewar, who, possessing the quintessence of the Rajput spirit, refused to acknowledge the sovereignty of the *Grand Mogul*. Moreover, Pratap insulted Raja Man Singh of Jaipur, the Rajput commander of the Mogul Army. The inevitable clash followed. No one has described the historic battle of Haldighati better than Colonel James Tod, an early eighteenth-century civil servant and chronicler of the Rajputs. His *Annals and Antiquities of Rajasthan* (Routledge & Kegan Paul, London) is a classic compendium. Our volumes have come down from my grandfather; and I quote a passage my father under-lined: 'In vain he [Rana Pratap] strained every nerve to encounter Raja Maun; but though denied the luxury of revenge on his Rajpoot foe, he made good a passage to where Selim commanded. His guards fell before Pertap, and but for the steel plates which defended his howda, the lance of the Rajpoot would have deprived Akbar of his heir. His steed, the gallant Chytuc, nobly seconded his

* Memoirs of Babur as quoted by James Tod

lord, and is represented in all historical drawings of this battle with one foot raised upon the elephant of the Moghul, while his rider has his lance propelled against his foe . . . Marked by the ''royal umbrella'', which he would not lay aside, and which collected the might of the enemy against him, Pertap was thrice rescued from amidst the foe, and was at length nearly overwhelmed, when the Jhala chief* gave a signal instance of fidelity, and extricated him with the loss of his own life.'

The battle was lost and Pratap's fortunes fell. He had neither food nor shelter for his family. The Bhil tribesmen and a faithful flock of followers were his only friends. Disheartened, he almost gave up. But then his luck changed, his old resolution returned. Before his death in 1597, Pratap had won back most of Mewar. Concludes Tod: 'Undaunted heroism, inflexible fortitude, that which ''keeps honour bright,'' perseverence, with fidelity such as no nation can boast, were the materials opposed to a soaring ambition, commanding talents, unlimited means, and the fervour of religious zeal; all, however, insufficient to contend with one unconquerable mind . . . Huldighati is the Thermopylae of Mewar; the field of Deweir her Marathon.'

The outstanding success of Mogul imperialism came about during the reign of Akbar's son, Jahangir; the Rana of Mewar acknowledged the suzerainty of Delhi. He was, however, exempt from attendance at the Court, and no princess of Mewar entered the Imperial harem.

Two generations after Jahangir, the Mogul dynasty declined. India became fragmented. Moguls, Rajputs and Marathas divided the country, opening the land for the merchants of the East India Company. From 1757, when Robert Clive decisively defeated Siraj-ud-daulah at Plassey in Bengal, to the uprisings of 1857, the British steadily forged their Empire. Thereafter, they left the princes to rule their states, under the careful watch of the political department of the Government of British India.

* My mother's direct ancestor

Under the Raj, with the steamship and the railway came new values. Also, a new voice. A group of nationalist Indians spoke out their grievances in English, using the rhetoric of European political thought. In the meantime, all the princes of India* attended the Delhi Durbar to declare allegiance to George V, the King Emperor. This was the most dazzling day for the Empire. A few years later Mohandas Karamchand Gandhi returned from South Africa and soon breathed life into the country's struggle for freedom. As Gandhi's influence roused millions of Indians, as one war in Europe followed another, it became inevitable the British would 'Quit India'.

Then, just before midnight of 14 August 1947, on the eve of Independence, Jawaharlal Nehru, India's first Prime Minister, gave that memorable speech to the first Constituent Assembly: 'Long years ago we made a tryst with destiny, and now the time comes when we shall redeem our pledge, not wholly or in full measure but very substantially. At the stroke of the midnight hour, while the world sleeps, India will awake to life and freedom.' Nehru also summarized history from the Rajputs to the Republic of India, when he wrote: 'Think of Chittor and its peerless story, of the amazing heroism of its Rajput men and women! Think also of our present day, of our comrades, warm-blooded like us, who have not flinched at death for India's freedom.'*

Soon, under the strong leadership of the Central Government, a process of integration of the Princely States into the Union of India began. Twenty-two states of Rajputana, the land of the Rajput leaders, merged to form Rajasthan*, A Place of Kings.

The Maharajas retained their titles and obtained 'privileges' and privy purses. Two decades later, these benefits were abolished by an amendment to the Indian Constitution. History had repeated itself. The princes failed to present a united front in their last 'battle'. Prithviraj lost at Tarain in 1192 because he did not

* Except Maharana Fateh Singh
* Jawaharlal Nehru in Glimpses of World History, Asia Publishing House, Bombay
* A name first used by James Tod

16

have the support of his brother prince, Jaichand, the ruler of Kanauj. Later Rajputs could not turn the Muslim tide, as petty squabbles overshadowed the common cause. The present-day princes blindly entrapped themselves in the politics of socialist India. They had not one but a hundred viewpoints. The roots of their disparities and defeat lay in their thousand-year-old chronicle.

The rich heritage and history of Rajasthan were the focus of my upbringing. But my bond with the past was severed, after my father's death, when our joint family broke up. In the English medium school and later at college in Delhi, I was, like many young Indians, attracted by the West, and eventually I went to live in Paris with my French wife. Still, I never considered myself an expatriate; every year I returned to travel to different parts of India, though not at first to Rajasthan. In time, the magnetic pull of the land of my birth began to assert itself.

I remembered the summers spent in my teens at my brother's farm in the hills of eastern Rajasthan. Before daybreak I would often watch herds of wild boar return to the safety of the cactus-covered ravines, after a night of feeding in the maize fields. In the early hours of the morning, partridges, parakeets and *langurs* rent the air with sharp and periodic calls. As the heat rose, sending most villagers indoors, the shrub jungle became quiet, broken only by the occasional cooing of pigeons or the grunt of a camel. In the late afternoons, as the heat receded, the birds and the animals became active again. After dark, one often heard the leopard's cough and sometimes we saw its eyes, two tiny torches gleaming in the distance. The herdsmen ensured that the livestock was corraled. At last, the predator moved away and the dogs stopped barking. After the warmth of the day, the cool nights lulled us into sleep. Some evenings, the Gujar villagers kept us awake. They had time on their hands, between the wheat harvest and the monsoon, to tell ghost stories, and to dance and sing.

I recalled how much the village people valued hospitality. I had gone to attend a wedding in rural Mewar. My uncle, the host, expected everyone to stay at least two weeks, since our large family was together only rarely. Those who wanted to leave after the nuptial ceremony had difficulty doing so. Their

baggage was hidden. One desperate guest left his baggage behind and slipped out of the house before dawn. But his absence was soon detected and a jeep dispatched towards the railway station, seven miles away. They found him hiding behind bushes, near the dirt road. I suspect they were really eager to prolong his stay because he was such a good cook. The three weeks I spent there are particularly memorable for the variety of Rajasthani delicacies we ate.

Over the centuries, the Rajputs have created a sophisticated cuisine. Their love for shooting game led them to devise delicately spiced dishes of rabbit, duck, partridge and quail, cooked on charcoal or in earthen pots. *Sulas* or wild boar roasted on a spit is the winter fare par excellence of the Rajputs. One inventive family made a delicacy I particularly relish, *kalezi-ka-raita*, a lamb liver dish served with a lightly spiced yogurt sauce.

I remembered my gourmet father supervising the making of aromatic liquor flavoured with aniseed, rose or saffron. Elsewhere in Rajasthan, over a hundred ingredients were used to make *Asha*. Distilled four to five times, it is Rajasthan's most fiery drink. In Jaisalmer it was even made from Imperial sandgrouse. Though the recipes for their cuisine were freely exchanged, the Rajputs held the secrets of making their potent spirits close to their hearts. This art is now a mere memory.

I remembered my mother's milder palate. She was a vegetarian and excelled in the making of sweets and snacks. As children we would jump with joy when we saw her making *mawa-ki-kachori*. On other occasions we would go to the *halwai* or sweatmeat makers, where with each festival new smells swirled about the shops. Jolly Ganesh, the *ladu*-loving God perched above the entrance to each Hindu home, has a weakness for good things, and so do the people who honour him.

A nostalgic longing for Rajasthan started building up in me. I longed for juicy mangoes and the sight of leaves swirling in hot gusts of wind, a harbinger of the coming monsoon. I longed to see those dark and dense clouds appear, like an armada of black sailed ships. I longed to soak in the first showers. I longed to

hear the piercing cry of the peacock, the sacred bird of Rajasthan. I longed to breathe the fresh air of September, when the receding clouds play hide and seek with the sun and the light dances on the green earth. In October and November, I wanted to participate in the festivals and fairs – Dusserah, when Rama kills the demon Ravana; Diwali, on the darkest night thereafter, when thousands of flares light up the sky to drive away the powers of evil; and the Pushkar Fair, the great camel and cattle market, whose origins go back into antiquity. Then in the cool of winter, which follows, I wanted to see those scores of monuments which attest to the proud past of Rajasthan. In 1974, I returned to travel in the land of my birth.

From the top of the citadel of Kumbhalgarh, I looked down at the broad and stolid ramparts snaking over the hills for 24 miles. From this height I could see the two diverse regions of Rajasthan: the wooded Aravalli Hills where I stood, and the Great Thar Desert in the distance.

At another end of the Aravallis rises the bastion of Chittor; it sprawls on a plateau, three miles in length and half a mile in width. As one approaches it by road its massive presence takes over. It was the focus of countless stories I had been told during my childhood. They were impressed in my mind with all the warmth and wonder of my mother's words. The great gateways, the cobbled pathways, Kumbha's Tower of Victory, Padmini's white pavilion – mirrored in a pool, the ruins of the palaces, the place of *jauhar*, the temples, the towers, the turrets all have their tales of triumph – not merely of arms but of the invincible mind. For eight centuries Chittor's story is of ups and downs, of splashes and sparkles, like a jewel turning in the hands of time. One of its memorable highlights is about the 'lotus-fair' Padmini. According to legend, she aroused the desire of Ala-ud-din Khilji, the Afghan, when he heard tales of her exquisite beauty. In 1303 he besieged Chittor. The Rana was held captive in the Sultan's camp. The defenders, led by Gora and the twelve-year-old Badal, rescued the Rana but could not resist the invader's organized strength. They chose death over dishonour.

What followed is described by James Tod: 'The funeral pyre was lighted within the great subterranean retreat . . . and the defenders of Cheetore beheld in the procession the queens, their wives and daughters, to the number of several thousands. The fair Padmini closed the throng . . . and the opening closed upon them, leaving them to find security from dishonour in the devouring element.' In two other sacks, thousands of Rajput women killed themselves on lighted pyres, by the act of *jauhar*, thus liberating their men to open the gates and rush in suicidal waves at the waiting enemy. This extraordinary courage and chivalry have made Chittor a place of pilgrimage for all Indians. I have visited it four times. My favourite spot is a secluded and sloping corner, where an aging peepul tree shades a small shrine. Here, each day at dawn, a priest performs prayers. In the distance, over the ramparts in the plain below, a cement factory belches smoke.

I am captivated by the towering strength of the fort of Jodhpur, perched on a ridge in sand-swept Marwar.* Kipling said it looked as if it had been built by giants. I have always shunned the motorway and preferred to walk through the narrow streets of the city, jostled by pedestrians, nudged by bicyclists, scooters and rickshaws, to climb to the top where the cannon are lined up, and to look at the maze of the streets below and the desert beyond.

Two hundred miles away, in the centre of the Great Thar Desert, is the twelfth-century fortress of Jaisalmer built on a caravan trail. Today one travels this ancient route by car or train. We have usually arrived when the last rays of the sun light up its yellow sandstone walls, turning it into a golden fortress. At the crack of dawn, we have scrambled up the crumbling pathway to the parapets to watch the sunrise give the touch of Midas to the sand-coloured city below us.

In the other half of Rajasthan, in the eastern Aravallis, a medieval fortress sits on the slope of a hill overlooking an old city. A highway passes above the town, but time has passed by this valley. On every occasion that I have driven on this road, I have been compelled to stop and look at it. Bundi's fairy-tale air is caught in the vibrantly coloured miniatures which were painted there.

* The historic region in western Rajasthan

There are so many forts in Rajasthan that I could fill several volumes. One of my favourites is also among the least known. On a narrow dirt track, 10 miles from Jhalawar, is rugged Gagron. Two converging rivers and cliffs chiselled by the rushing waters act as natural barriers. Inside are three lines of defence, fortresses within a fort. Today only parrots and monkeys inhabit its crumbling interiors.

If the forts of Rajasthan attest to its martial past, its cities speak of peaceful times and the princely builders' fascination with art, architecture and science. My hometown Jaipur was built in 1727 by the astronomer and mathematician Maharaja Sawai Jai Singh. He planned Jaipur after a study of ancient Hindu treatises and contemporary European town plans.

Most Indian builders of traditional temples and towns made dramatic use of sunlight. It is a passion rooted in our worship of the rising sun. At dawn it shoots above the sacred Galta Hill, over *Surajpol* the Sun Gate and lights up *Chandpol* the Moon Gate, near my home. Its soft rays illuminate the Hanuman Temple before which flocks of pigeons alight to be fed by worshippers. It then travels up the 108-foot-wide main street and its three large squares. Gradually it lights up the shops, the houses, the domes, the corbellings and balconies, all of which are painted pink. At first the city was whitewashed, but the glare of the tropical sun forced the architects to turn it into the Pink City. The narrow side streets, divided into quarters for different professions, receive little direct sunlight, allowing cool air to lie trapped there all day.

In this fusion of eastern and western town-planning is a wonder of functional geometry, the *Jantar Mantar*, the Observatory conceived by Sawai Jai Singh. He built similar structures at Delhi and at Ujjain, Benares and Mathura. Today, we admire these as works of art whose surrealistic shapes of marble and stone seem to echo the mysteries of the sun, the moon and the stars.

I have always thought of Jaipur as my father's city and Udaipur as my mother's town. The capital of Rajasthan has masculine appeal while the capital of Mewar is endowed with feminine charm. Whereas the Pink City is a place of formal grace,

straight lines, right-angles, logic and geometry, the City of Sunrise has all the surprise and delight of narrow and meandering streets, of ups and downs and the intuitive mind. Udaipur is a lake-side city of island pleasure palaces, white-washed houses and fountains playing in lush gardens.

More than any city in Rajasthan, Jaipur suggests its close links with the Mogul courts. The pragmatic attitude of its rulers made it a prosperous city right from its beginning. Its jewellers, idol makers, textile merchants, its weavers, dyers, brass and enamel workers have always sent their products to different parts of India. On the other hand, Udaipur mirrors the simpler life of the early Ranas of Mewar. Its betel-nut vendors, the peasants selling wood, the cloth merchants, the ivory carvers and other artisans go about their work with a sense of modesty. Here, in contrast to Jaipur, cars, scooters and motorized rick-shaws are few. In this quiet town, walking past the martial frescoes, I have heard not the honking of horns but the peal of the temple bells. This is Rajasthan's most traditional town. Its quiet charm has lured me into visiting it countless times.

But beyond the cities and the forts, in the villages set in sand and shrub, the elemental life of the peasants, periodically punctuated by fairs, festivals, songs and religious ceremonies, speaks more than anything else of the rich heritage of Rajasthan. I had, of course, glimpsed some of this during vacations spent in scattered villages where my father owned land. But these experiences were limited, a child's look at a close yet distant world.

One hot summer, as my wife and I drove down a dusty desert road, a woman crossed with a pot on her head, drawing our attention to a well. In the scorching heat of May, a crowd buzzed around the only source of water in Galawas, a village near the city of Jodhpur. Here, as in most of Rajasthan, water is scarce, especially during the summer. The well is the focus of life. 'The water level stands at three feet,' exclaimed Bhanwar Singh, a bright-eyed and moustached villager. 'We are careful. The few animals left in the village are allowed to drink only at night, when they are less thirsty.' As I looked around, I saw no livestock, only a

sweating human chain tugging at a rope attached to a leather bucket, emptying the precious content into a trough from which the pots were being filled. Four other villages used this well, but only for drinking water. Months before, most of the sheep, goats, cattle and camels had been driven away towards the Chambal River to graze, though the farmers there violently oppose these migrant herders. Some sent their livestock to the Rajasthan canal or even to the Ganges.

The rains usually come in cycles, every two or three years. In the worst years the crops are totally lost and famine prevails. In 1975 13,000,000 people were affected in Rajasthan. Said one villager: 'When the rains failed we performed a *hom* [prayer around a sacred fire] and we remained four hundred rupees poorer. It rains only when the gods are pleased.'

In this area there is only one crop: wheat planted in early winter or millet sown during the monsoon. Therefore, even in a year with good rainfall, the villagers depend on dairy products and wool for part of their sustenance. 'In bad years we have to buy our grain from the city,' said Bhanwar Singh, 'for which we borrow money at exorbitant rates of interest.' Despite his circumstances, Bhanwar Singh kept his good humour. I was struck by his cheerfulness. I asked him how he managed in this period of drought. 'I have eaten only a bit of gruel today,' he replied. Then, pointing to some dry thorn trees, he added, 'We make curry out of the beans from these *khejra*. Further in the desert, *bhroot*, a prickly grass, is ground for consumption. Wool brings some money, manure sells at a rupee for every twenty kilos, but now as our animals have been sent away to graze, we have little to go by. Of course, there is always the moneylender.'

When life is normal the villagers eat pearl millet *rotis* (unleavened bread), pulses, buttermilk, onions, sometimes a little potato or beans. *Rabdi*, a gruel cooked after mixing millet flour with buttermilk, and *khich* cooked with water, millet and pulses allows significant savings in grain consumption. Most families also own cows. One cow gives about three litres of milk during droughts and six litres when properly fed. One to two litres are sold at a rupee each but most of it is converted into buttermilk and curd for the family.

23

We moved to Bhanwar Singh's mud-and-thatch house. At the entrance, there were three large cowdung-plastered bins for seed. He lifted the lids to show they were empty. Leaning against one of them was the priest, a tall and slightly built brahmin. He lived in a neighbouring village and visited Galawas twice a week, attending to weddings, funerals, births, drawing horoscopes and forecasting auspicious occasions. A cloth bag hung from his shoulder, in which he collected payment, in grain. 'This year I have little to take away,' he said.

Then Bhanwar Singh led us to an uncompleted single-room structure, the primary school. 'We have contributed thirty-one rupees per plough to raise this. But now we cannot spend any more and we fear that when the rains come they will wash it away.' A part of the temple served as the primary school. Fifteen boys attended the middle school in a nearby village. Asked about the girls, one elderly villager remarked : 'We don't send them out of the village. If a girl gets too bright, what use will she be to her husband?' No one in Galawas was educated beyond the sixth grade. 'We sign with this,' said the old man holding up his thumb.

As we were leaving, we walked past the shrine of *Mamadev*, the guardian deity of the village. This was a powerful stone image, propped up on a mound by the bank of a dry pond. Small wooden horses lay about in the sand, offerings at a festival. 'When the spirits gather here three times a year, you can see from a distance a flame burning,' said Bhanwar Singh. 'Then no one dares come close. We make regular offerings of coconut or boiled wheat.' On the road, further into the desert, well after well was the centre of life. The *loo*, a hot gusty wind that blows fiercely during the summer months, descended on us. Sometimes, it kills.

In Rajasthan, there are thousands of villages like Galawas and hundreds of others which are worse off. My aim in writing about this village is not simply to show its wretchedness. I find it futile to add to the volumes written on the poor of India. But it is important to point out that in spite of this poverty, the peasants of Rajasthan have spun out a wealth in folk culture. Their exuberance, their vitality, their ability to laugh, to sing and to dance, interwoven into the rich

fabric of their culture, makes them stand out. Whatever their names – Karna the Bhil, Bhanwar Singh the Rajput, Churaman the Jat, Kamu Khan the Muslim, Mahadev the Mina, Arjun the Gujar, Ganesh the Girasia or any of the different communities who make up Rajasthan – one cannot fail to be inspired by them. Even the clothes they wear, those bright and vivid fabrics, are a symbol of their colourful spirits.

I felt some of this ethos of Rajasthan in 1968, during a visit to Jaisalmer. I went there to watch Satyajit Ray film a musical, *The Adventures of Goopy and Bagha*, based on a fairy tale by his grandfather. I had never been to western Rajasthan before and this visit cast a spell on me. At the end of a day's filming, magically two musicians stepped out from a mass of men and camels. They walked down a path playing a haunting duet on their *alghojas*, the double-flutes.

I had also noticed a man full of pride and mystery. His enormous black moustache was coiled on his cheeks, his head was swathed in a white turban and his weather-beaten face spoke of the harsh life of the desert. He carried a sword and what looked like a stick. I realized that the crowd knew him and held him in awe. There were whispers of *daku* (bandit)! Six years later I came to know Karna Bhil, the bandit-musician. He still carried the stick-like object, the *narh*, a four-foot-long flute. Sitting on his haunches, body swaying from side to side, he played it. Its long and soulful notes echoed through the desert. With a rasping sound he sucked in air deeply, played a last note, and stopped. Then Karna Bhil, one of the living legends of the Thar, spoke of the code of honour of the *dacoits* (bandits). As they have for centuries, some *dacoits* still rob only the rich, and only in daylight. He talked casually of a jailbreak, when he dug his way out of his cell 'with my bare hands'. Long periods of imprisonment have given him the leisure to attain perfection with the flute. When I met him he was free, living as a farmer. 'I love to play the *narh* at night, camped out alone in the sand dunes,' he said.

To hear more music and see the people of the Thar, I went to the Tilwara Fair. I was fortunate in being accompanied by Komal Kothari, an unusual man.

He is a *bania* by birth. This caste of businessmen, among whom the Marwari community of Rajasthan is prominent, controls most of the commerce and industry of India. But Komal is a musicologist. As far as I know, he is the only professional of his kind living in a village the year round. No one is better versed in the village lore of Rajasthan than Komal. He had already visited the Tilwara Fair three times.

The Fair is held along the Luni, a capricious monsoon river, and the only significant stream west of the Aravallis. In flash floods, its torrential waters sweep away unwary villagers and sometimes even bus-loads of them. I saw it in flood once and witnessed its power and fury, which I had never suspected when I had seen its dry summer bed. Despite the damage it causes, there is a saying that half the cereal produce of the region is a gift of the Luni. Shortly after the spring harvest, the river has enough subsoil water to allow the Tilwara Fair to be held.

Around hundreds of water holes, the menfolk* of the desert and those of the neighbouring States were camped with thousands of camels, bullocks, cattle and horses. This temporary township stretched for a few miles along the Luni. A central marketplace was a jumble of shops selling camel and horse saddles, pots and pans, plastic buckets, ropes, knives, swords, clothing, carts, and other items for the home and the field. Preceded by bouts of bargaining, purchases were made to last for at least a year.

All day, the bed of the river was a long track for prospective buyers trying out galumphing camels and swift horses. Herds of cattle being brought to the fair kicked up clouds of sand. At dusk, when the action and the dust began to settle, fires were lit to cook the evening meal.

Komal and I had gone around looking for his musician friends. We met many of the best. He was greeted with embraces. Over the years, Komal has promoted them; some have even accompanied him to perform in Europe. From their music

* No women attend

26

he has arranged for several discs to be cut by the Musée de l'Homme in Paris. My favourite is the *Flutes du Rajasthan*.

On the sloping banks of the Luni, with campfires all round us, and some distance from the blaring loudspeakers and neon lights of the bazaar, we formed a circle. In the centre, with sharp features and soulful eyes, were the musicians: Hakim Khan, playing the *kamayacha*, a string instrument; Kamu Khan with his Jew's harp; Biarsi Khan, the drummer, and Ramzan Khan, Chanane Khan and Bhungar, a trio of vocalists. Ramzan Khan, the twenty-three-old singer, surprised us with his skill at improvisation. Biarsi Khan displayed a rare technique in playing a composition set in the *dadra tal* rhythm. But best of all was Bhungar. His tattered white shirt and pock-marked face were deceiving – once he started his spirited songs, the crowd applauded wholeheartedly. He was requested to sing again and again.

During intervals I could hear snatches of music drifting in from other camps. These were professional musicians performing for their patrons, with whom they have been linked for generations, discharging their duties at festivals, religious ceremonies, weddings and births. Payment is made in kind: food, clothing, household articles and sometimes livestock. One group of professional musicians, the Langa, are bonded to a caste of cattle-breeders. Some Langas live in Barnawa, a village of conical thatched huts set in sand dunes. What struck me here was that every inhabitant had some musical training. Even while going to fetch water from the well, the children were beating a tune on the empty vessels. These young Langas are instructed by a time-honoured oral method. During these few weeks the initiate learns the technique of playing an instrument and some basic melodies. Thereafter, the aspiring musician accompanies experienced artists. If he is to become a singer, he will memorize thousands of traditional couplets before he acquires the art of improvisation.

A group of three Langas, Nur Mohamed, Aladin Khan and Shumar Khan, are widely known throughout Rajasthan. In Jodhpur, at the Rajasthan Sangeet Natak Akadami (an institute for the promotion of music), I listened to these musicians

sing to the accompaniment of the twenty-seven string *sarengi*, a bow instrument; they concluded their performance with a passionate ballad which evokes such intense emotions that it is always sung as the finale. The Langas declare: 'There is nothing after Nagji.' This ballad is popular among the herdsmen of the desert. It is their Romeo and Juliet. Nagji loves Nagwanti, but the latter's family has arranged for her to marry another man. She vows to escape before the nuptial ceremony and Nagji waits until the appointed hour. When she does not arrive, he believes she has deserted him, climbs onto a tree and stabs a dagger into his heart.

But Nagwanti was only delayed in her escape. Terrified of ghosts and demons, she searches for her lover, thinking he is playfully hiding. Finally she too climbs onto the tree but finds only his limp body. The ballad ends with the death of Nagwanti as she jumps onto the funeral pyre.

Unlike the tall, turbaned men of the Thar Desert, the short, stocky Bhils live in the Aravalli Hills. They are Rajasthan's oldest inhabitants. In the story of Mewar, these people have played a prominent part alongside the Rajputs. The royal crest of Mewar shows a resplendent sun with a Rajput on one side and a Bhil on the other. In spite of centuries of contact, these tribals have maintained a distinct identity and way of life. I have visited them in their huts perched on hills overlooking ploughed fields. But the time to enjoy their company most is during the monsoon. I have a vivid memory of their celebration in honour of Gauri, the consort of Shiva, a forty-day-long festival of dance and drama which travels from village to village. The main act shows Gauri seeking the aid of Shiva and killing the demon who wanted to entice her away. This day-long drama is broken up by comic skits, the beating of brass plates to accompany the dancing and shouts of '*Charbhujaji ki Jai*, Victory to the four-handed Vishnu'.

In a small hamlet, as the sun went down behind the Mewar Hills, the Bhils brought to an end the day's performance. The village women gathered around them and marked their foreheads with vermilion, blessing them for destroying the demon and for the triumph of Gauri, the goddess of abundance.

When the hills of Mewar no longer echo the singing of the Bhils and winter has given way to spring, when the mango tree and the flame-of-the-forest flower and the crops are harvested, it is time again for festivities. The lively tribals of Sirohi District, the Girasias, dance and sing from field to field, from hut to hut, collecting gifts of sweatmeats or coconut. Escaping from the coloured water splashed about, in Mount Abu during the revelry of Holi, I found myself surrounded by dancing Girasia girls. They sang, asking for coconut or money. I was happy to oblige them and this brought forth giggles and peals of laughter.

The women of Rajasthan, whether they are the lively Girasia girls of Sirohi, the buxom Bhil women, the tall and graceful women of Jaisalmer, the devout women like my mother, or the women stepping out of the pages of history like the proud and 'lotus-fair' Padmini – whatever their caste and creed – represent the beauty, the courage, the loyalty and the devotion for which Rajasthan is renowned. And above all stands Mira Bai, the poetess-princess, whose *bhakti*, or passionate self-surrender to the supreme spirit, has made her so famous that her songs are sung from the snow-clad top to the surf-washed tip of India. The daughter of Rao Ratan Singh, a sixteenth-century noble of Marwar, she was married into the princely family of Mewar. The death of her husband, in the prime of her youth, gave her the freedom to devote herself entirely to the Lord Krishna whom she had worshipped from childhood. Leaving Mewar and the royal court, she became a wandering minstrel and finally lived in Brindaban, the birthplace of Krishna. A legend has it that, while dancing in front of a portrait of Krishna, she invoked his everlasting affection. The Protector and the Preserver reached out and embraced her. Thereupon she disappeared from the earth. The story of Mira Bai has been the delight and inspiration of Indians through the centuries.

'. . . the sound of Krishna's flute is the voice of Eternity heard by the dwellers in Time,' wrote A. K. Coomaraswamy, the great scholar of Indian art. Krishna, with his slate-blue skin a symbol of the sky, his golden shroud a symbol of light, a crown of peacock feathers a symbol of the rainbow and a garland of wild

lotuses a symbol of the wild woods, is worshipped from the most splendorous palace to the most modest hut.

Fifteen years ago, during the festival of Gangaur, I went to Kishangarh. In the Maharaja's fort, on a moonlit night, I saw gorgeous girls, dressed in silk and brocade, dancing before the images of Krishna and his consort Radha. As the Maharaja and his guests watched from a terrace, the evening reached a climax with the lithe dancers whirling round and round, balancing on their heads brass pots full of burning coal. In their ecstasy, they had surrendered themselves to the seductive sound of Krishna's flute.

In 1943, a poet and lover of painting, Eric Dickinson, visited Kishangarh. There, he was first shown a pile of miniatures which he found uninteresting. Then, with some hesitation and caution, a portfolio of large paintings was brought out. 'Now before our astonished gaze . . . In the few paintings passing in review before us was revealed an amazingly tender, sensuous, yet over-refined Krishnaite world . . . Who could imagine so sensuous yet refined a treatment of the loves of Radha and Krishna as here was now revealed.'*

Through this chance discovery, we came to know the elongated face, the firm forehead, the boldly arched eyebrows, the up-tilted doe-like eyes, and the sharp, pointed nose typical of this highly stylized art. It was the work of Nihal Chand. His patron, a mid-eighteenth-century Raja and poet, Sawant Singh, had the bewitchingly beautiful singer Bani Thani as his mistress. They had two passions: love for Radha and Krishna and love for each other. In this religious and romantic atmosphere, Nihal Chand most likely fashioned the features of the divine lovers after the enchanting Bani Thani. The Kishangarh paintings were the last great work on the Krishna theme. Already, the other Rajas had lost their infatuation with the god of the green pastures.

In the meanwhile, Rajput painting remained rich and diverse until its decline in the second half of the nineteenth century. It portrayed the prince, the palace,

*Eric Dickinson, 'The Way of Pleasure: The Kishangarh Paintings', *MARG*, Vol. III (1949), No. 4, p. 30

the poem, the hunt, the legend, the folk tale, the myth, the musical mode and the erotic scene. There were almost as many styles as subjects. A sophisticated sensitivity had emerged from the interaction of Mogul and Rajput cultures. But while Mogul painting, with its fine detail and emphasis on description, is like great reportage, Rajput painting is expressive, intense and poetic.

The Kotah style stands apart. It was the finale of an epic ballad. In the hunting scenes, this atelier skilfully fused the refinement of the Moguls with the vigour of the Rajputs. The dash and detail of this school fascinate me. I went looking for the setting which had inspired the Douanier Rousseau world of Kotah painting. I made a trip down the Chambal, Rajasthan's only perennial river. The shooting boxes still stood, but the jade green jungles and the tigers, the wild boar and chital had disappeared. The noble Chambal was no longer a river flowing through Rajasthan's past, it was the fast-flowing stream around which are set the 'temples of modern India' (as Nehru called them), its dams and factories.

Like Rajasthan, I too have changed. In the storied forts, the magnificent palaces and the walled cities I have been enticed by history and art. At home, seeing my mother light an oil lamp and pray, I have been touched by her devotion. Yet, alongside Kumbha, Pratap and Jai Singh, I now uphold Gandhi, Tagore and Nehru, the architects of modern India. Through their endeavours education, emancipation and industry have grown. In Rajasthan, we now have a zinc-smelter, an electronics factory, textile mills and a nuclear power plant. Cars and scooters have found their way into the lives of the middle class. The refrigerator and television set are monuments in the living room. In the villages, the transistor, the bicycle, the electric bulb, the occasional tractor and the water-pump have a permanent place.

If some of the fruits of the twentieth century have reached the city and the countryside, it does not mean we have substantially absorbed the modern experience. We will do that only when we begin using with ease and grace the products of our century, not merely for our commerce and comfort, but also for

our artistic aspirations. Only then will we create our equivalents of the Kishan-garh and Kotah paintings. In the meantime, our sole democratic arts will be those of the village folk, who, echoing the life of the remarkable Rana Pratap, live in the hardship of shrub and stone. There, the sacred peacock gives his piercing cry and the proud camel winks.

June 1980 Raghubir Singh

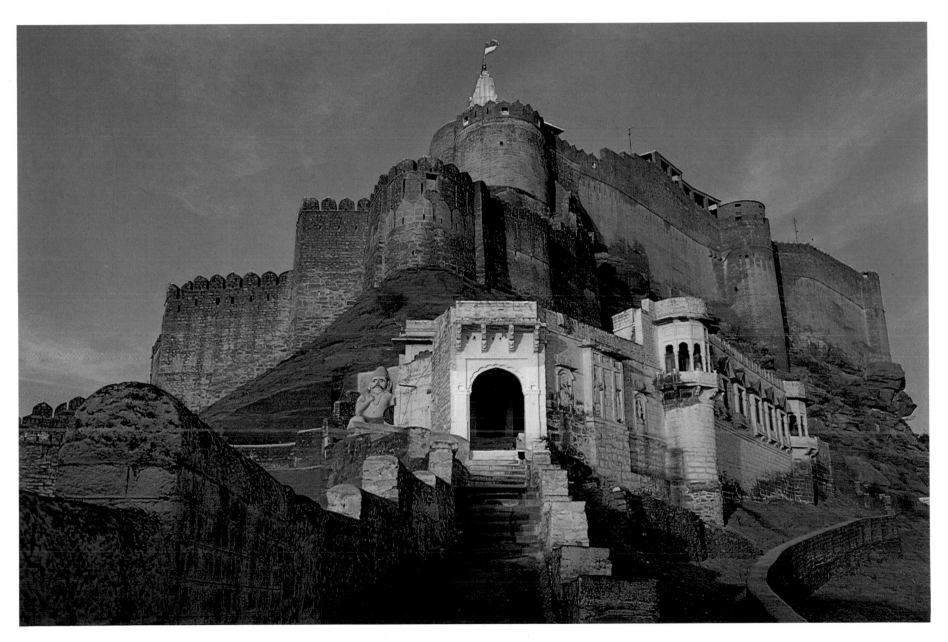

1 *A section of the mid-15th-century Jodhpur Fort.*

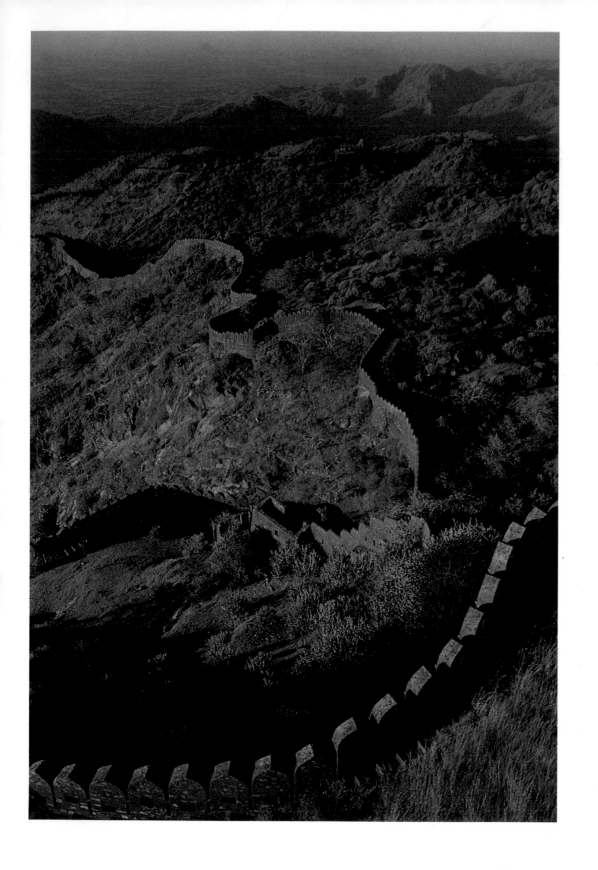

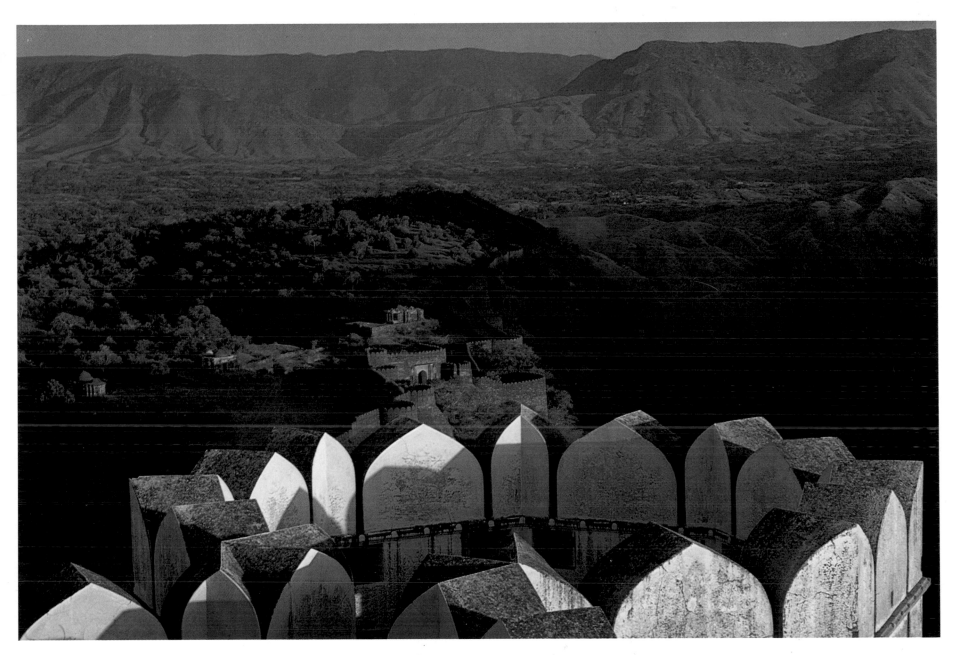

2/3 *The ramparts and battlements of the 15th-century Kumbhalgarh Fort, Mewar.*

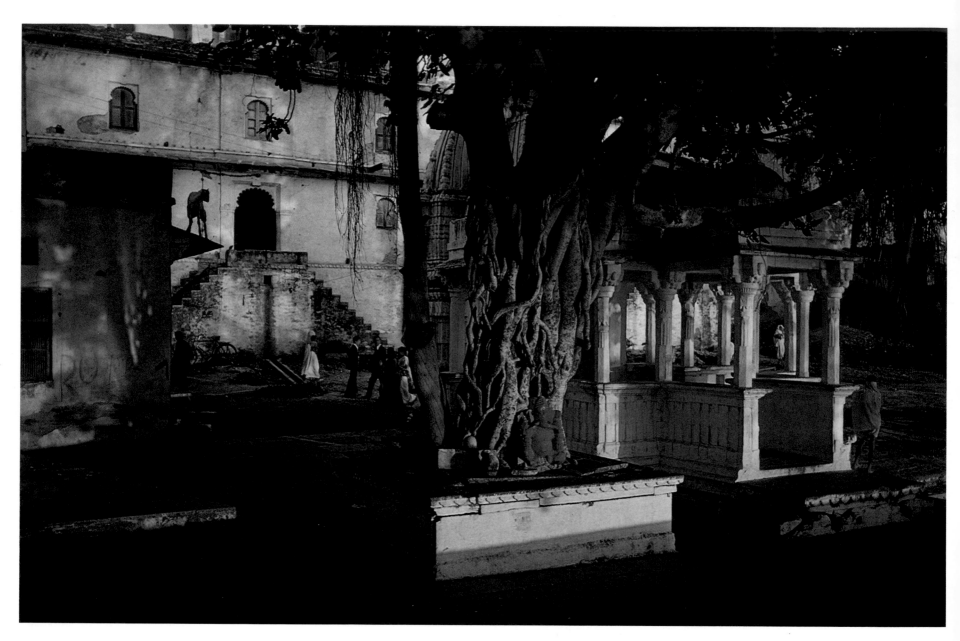

4 *A shrine to the god Ganesh, the remover of obstacles, Udaipur.*

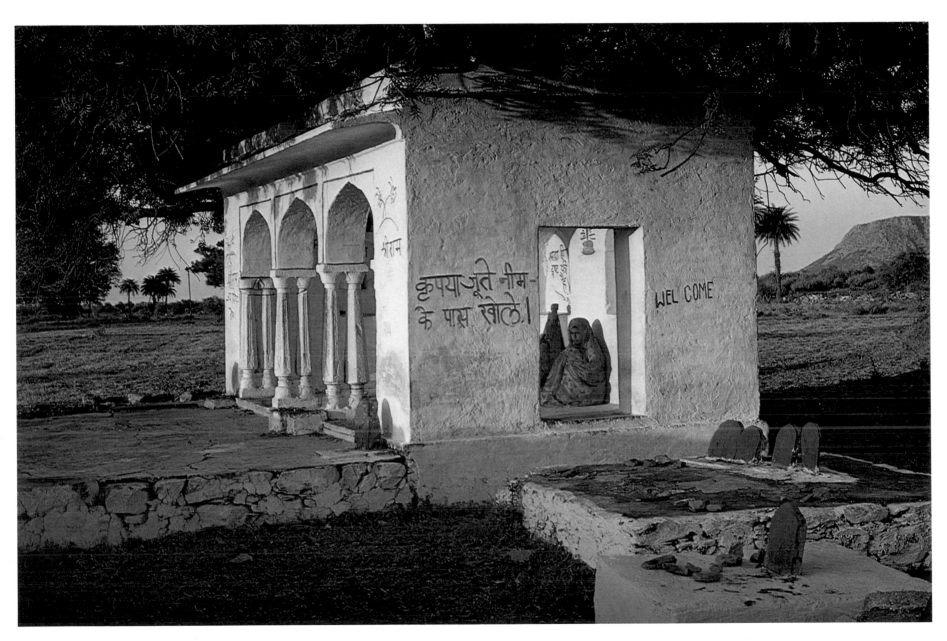

5 *A woman in meditation, Nawand village, eastern Rajasthan.*

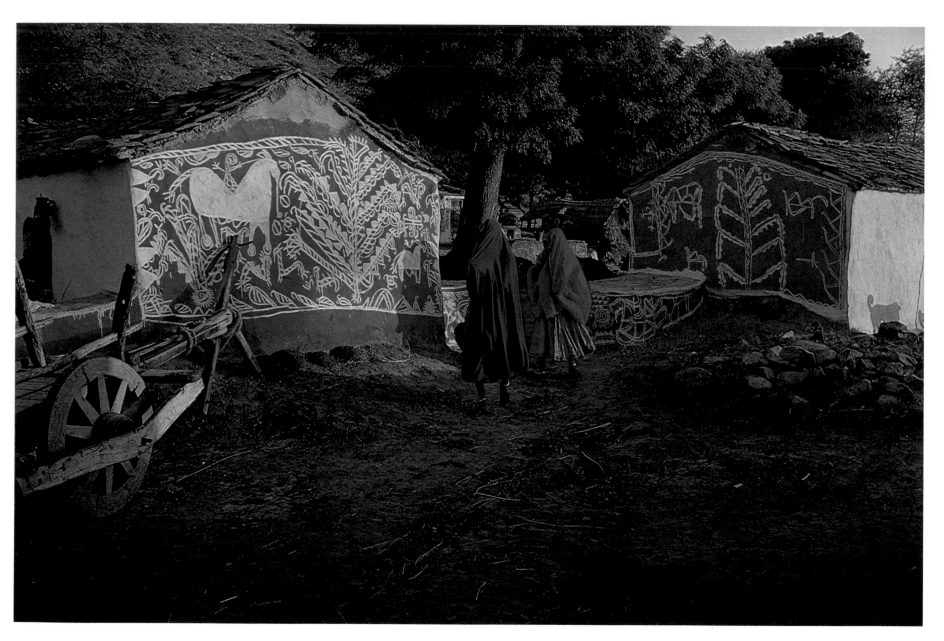

6 *Gujar huts with festive Diwali decorations, Nawand, eastern Rajasthan.*

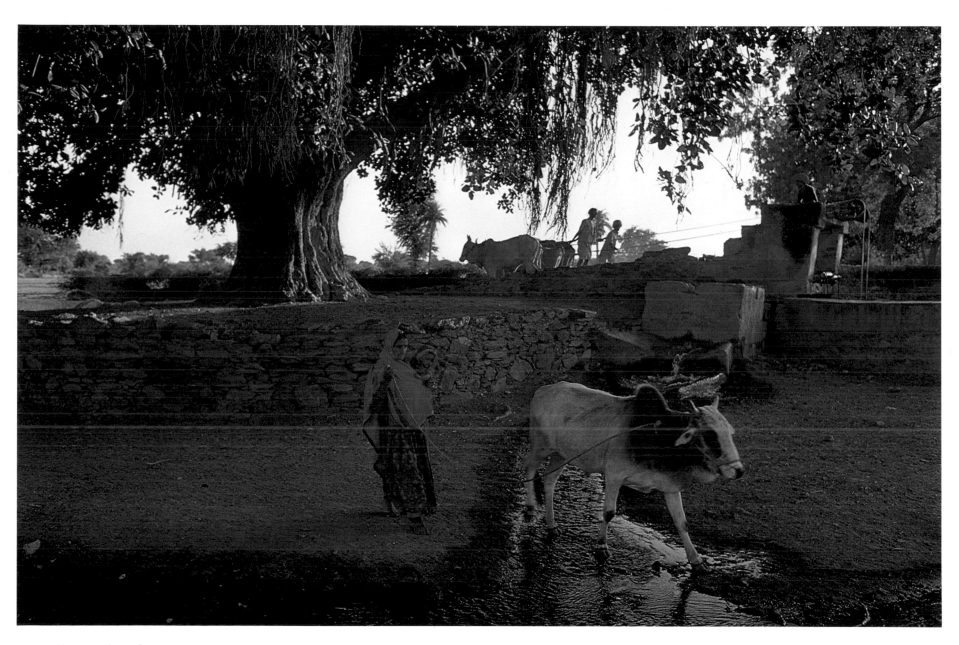

7 *A village well, Badnor, Mewar.*

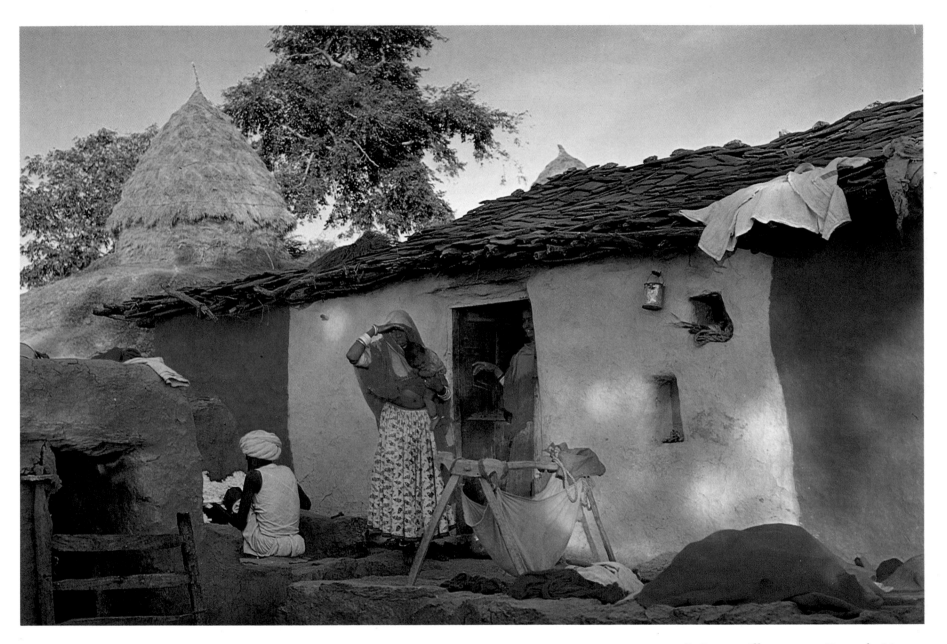

8 Rawat villagers near Deogarh, Mewar.

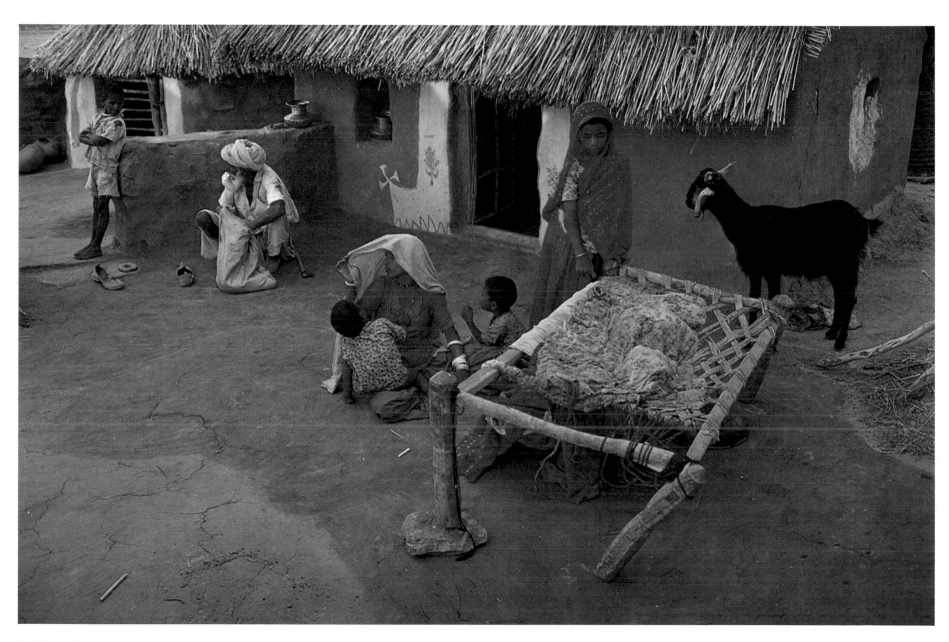

9 *The village Danvara near Osian, Marwar.*

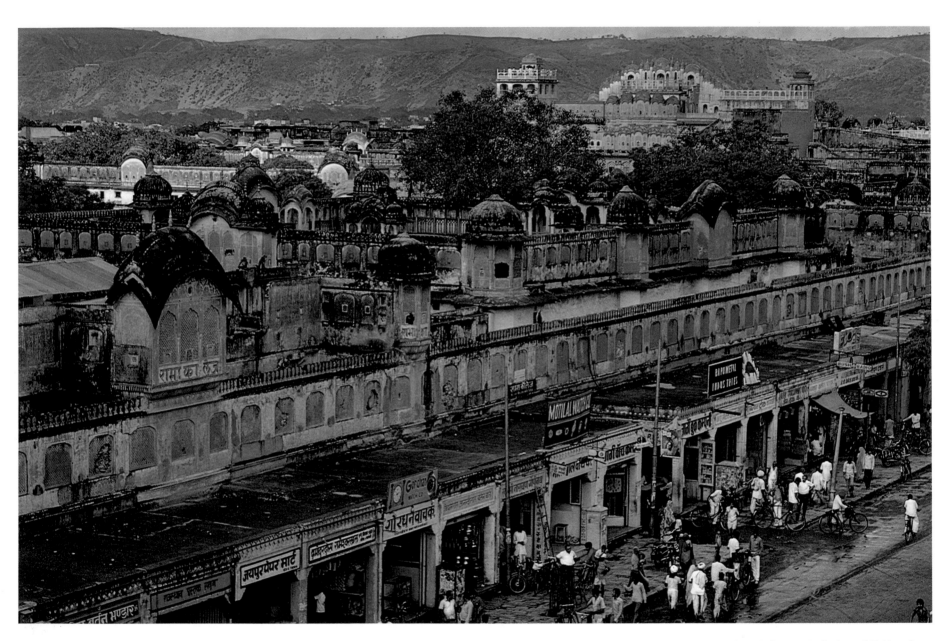

10 Jaipur, the capital city of Rajasthan.

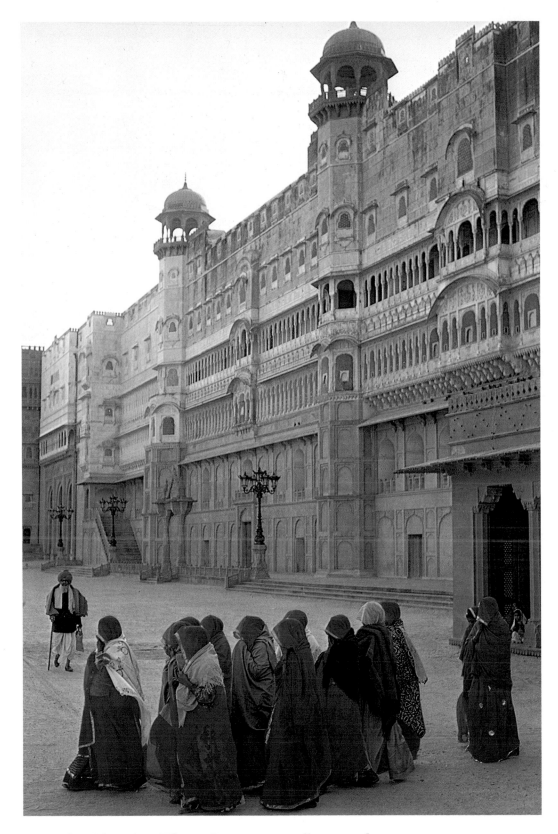

11 In the 16th-century Bikaner Fort, women walk to attend a ceremony.

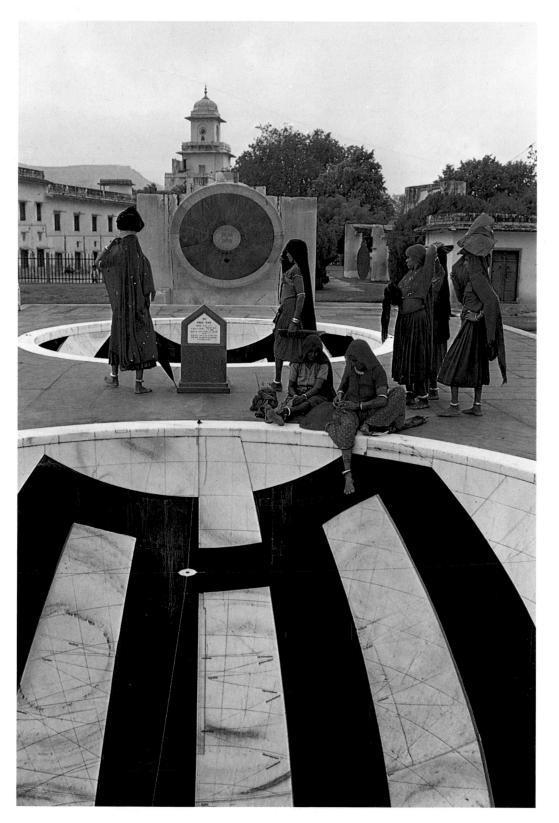

12 The Jantar Mantar, *the early 18th-century Observatory, Jaipur.*

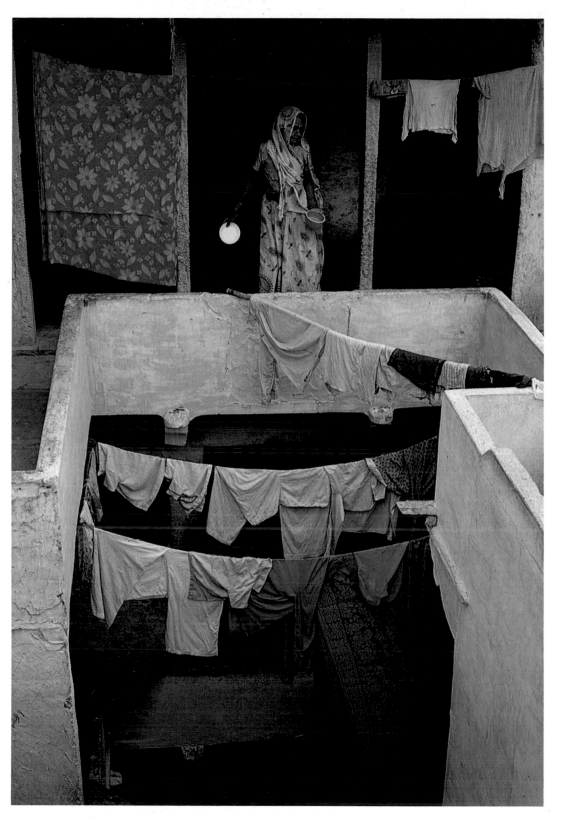

13 *Housewife and laundry drying over courtyard, Jaipur.*

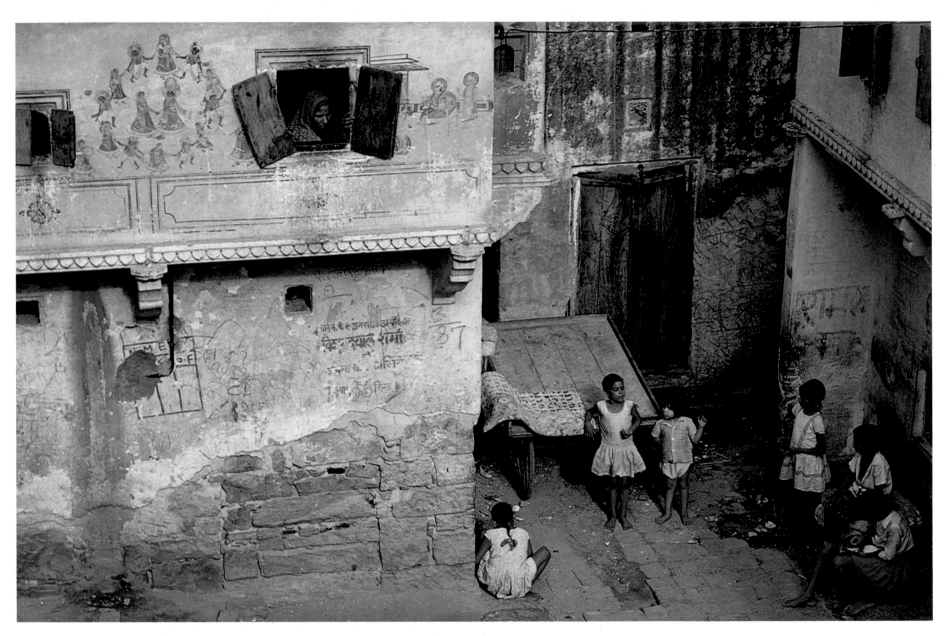

14 *A housewife looks out, children play, the god Krishna depicted dancing in a wall painting, Jaipur.*

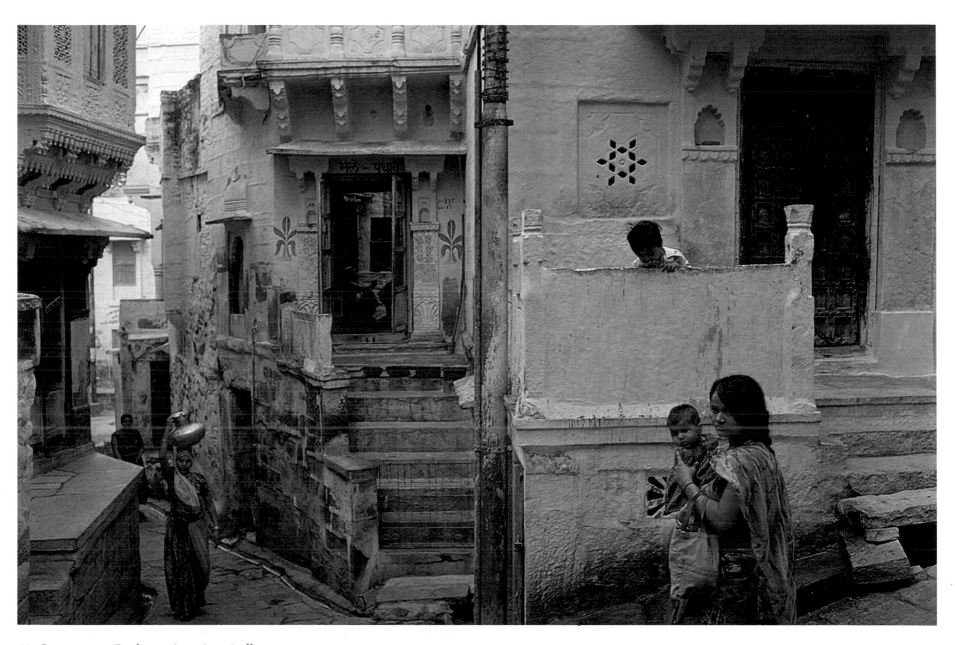

15 *Street scene, Brahmpuri section, Jodhpur.*

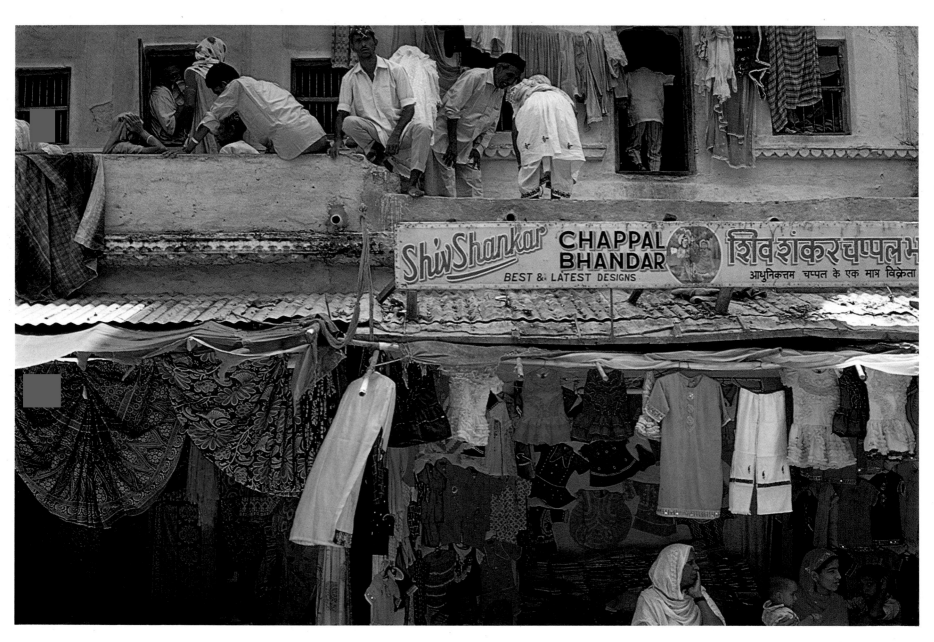

16 *Textile shops and Muslims before prayers at a nearby shrine, Ajmer.*

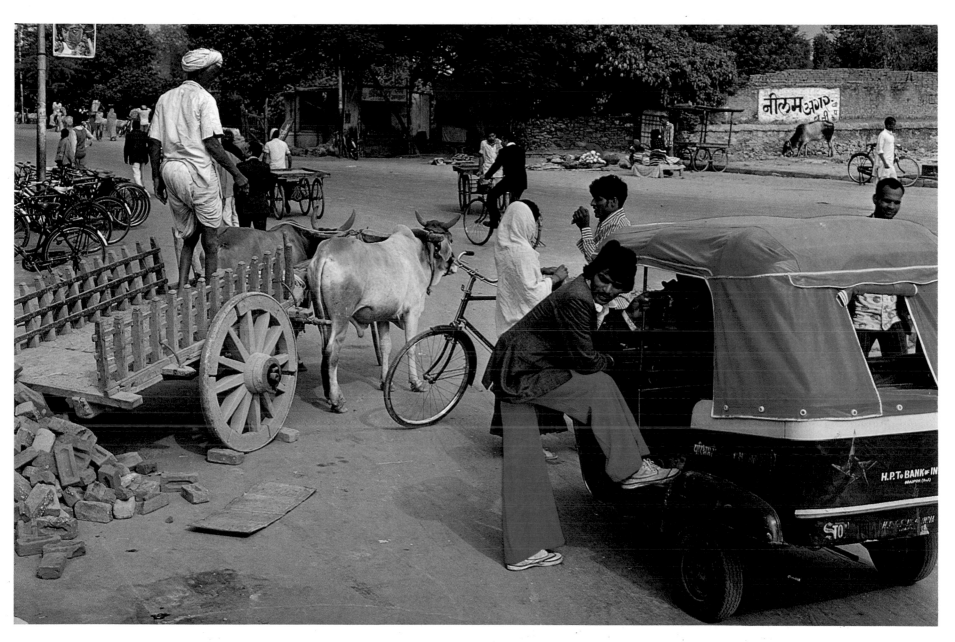

17 *Street scene, Udaipur.*

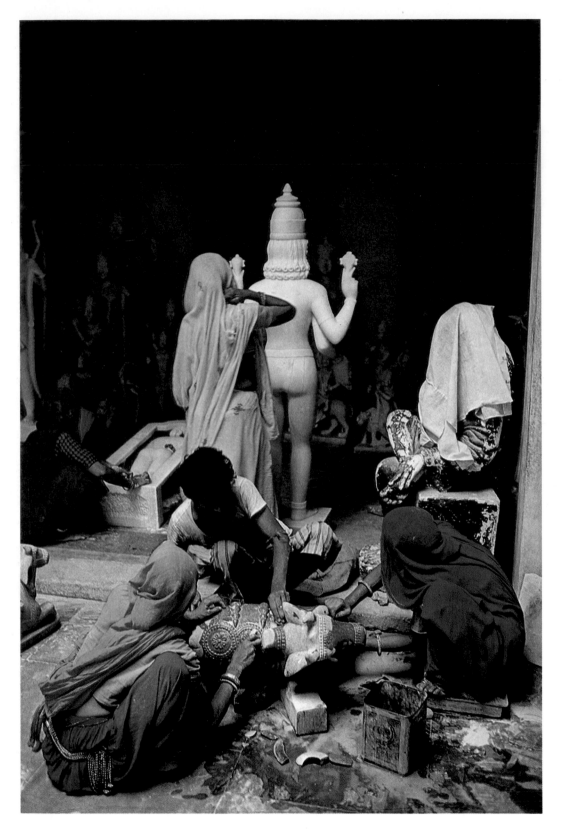

18 Artisans sculpt and polish stone and marble statues, Jaipur.

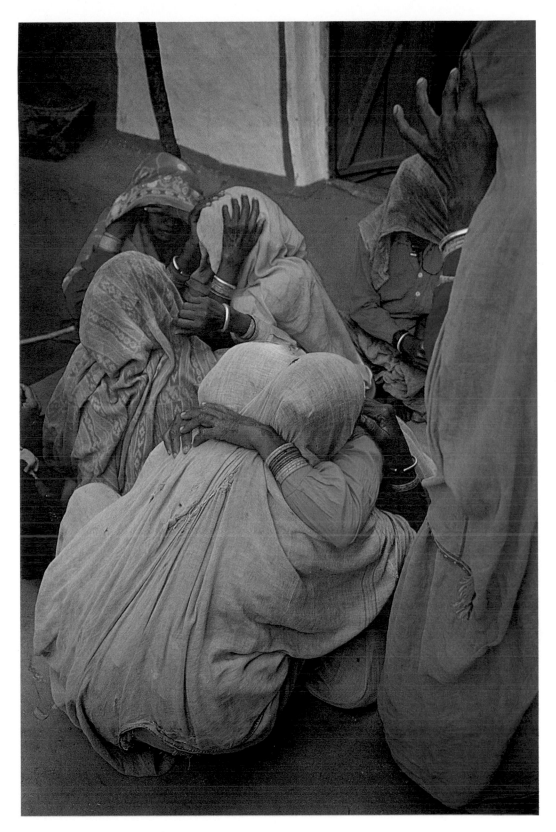

19 *Women mourning, Bharatpur.*

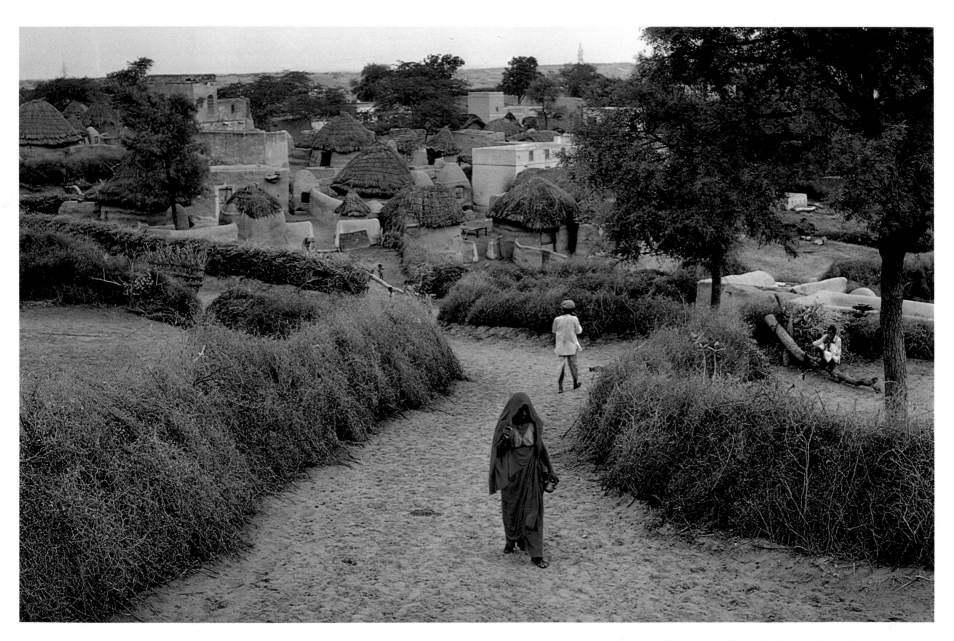

20 *A village path between thorn-bush corrals, Bikaner District.*

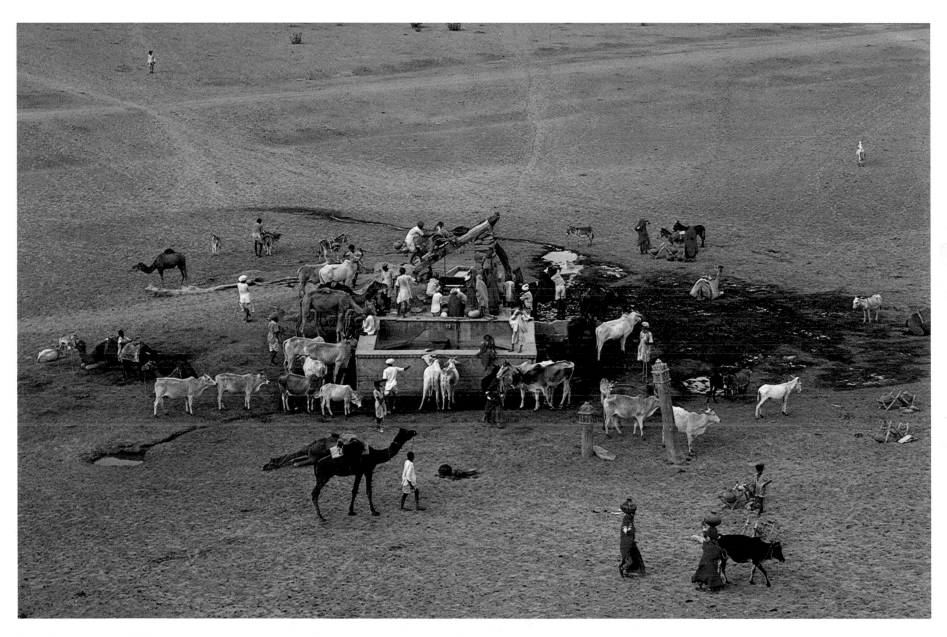

21 *The village well, Barnawa.*

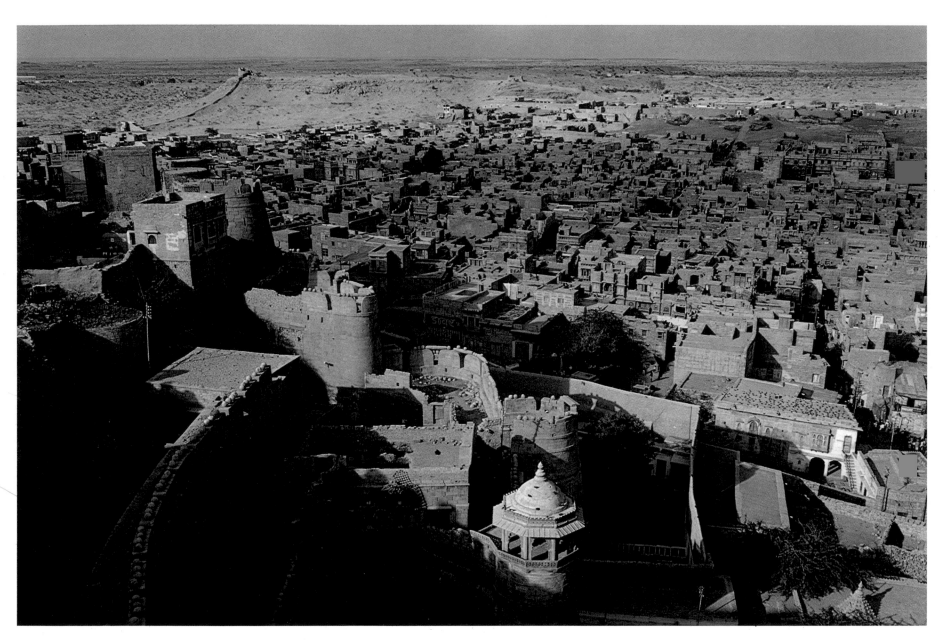

22 The 12th-century Jaisalmer Fort and town.

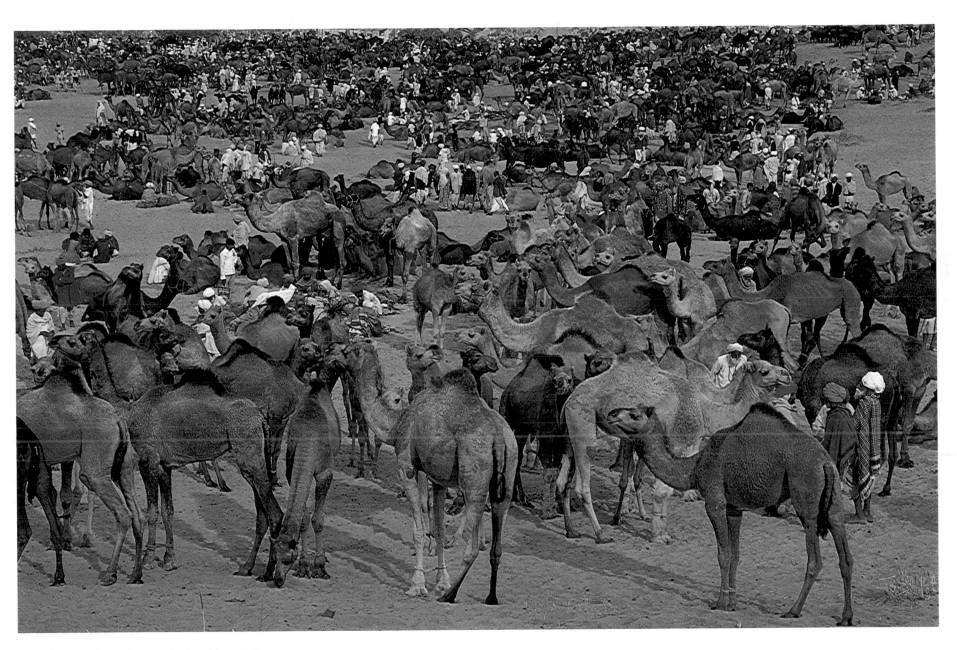

23 *The camel market at the Pushkar Fair.*

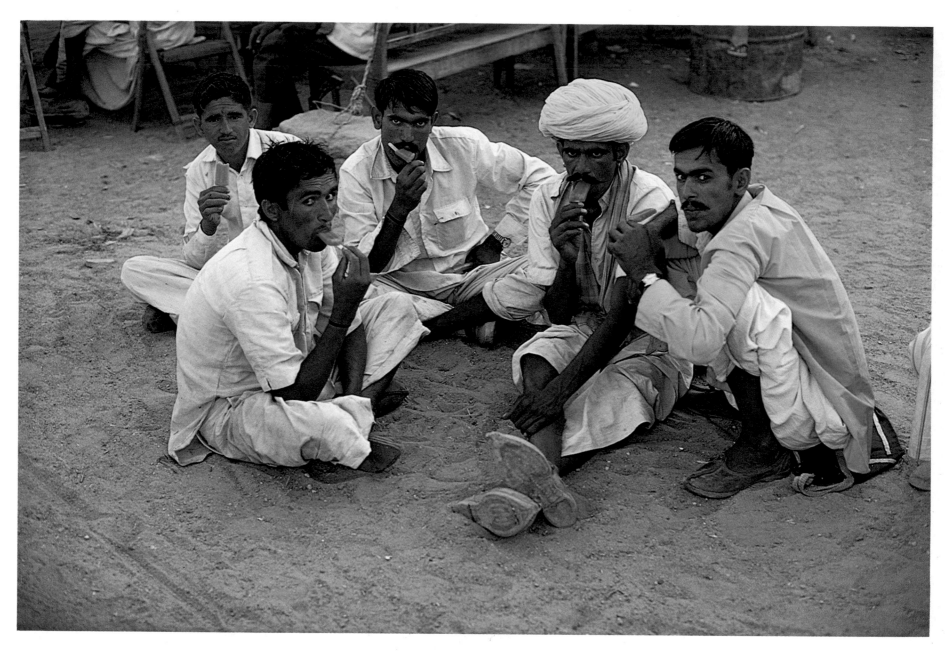

24 *Villagers visiting Jodhpur enjoy iced sweets.*

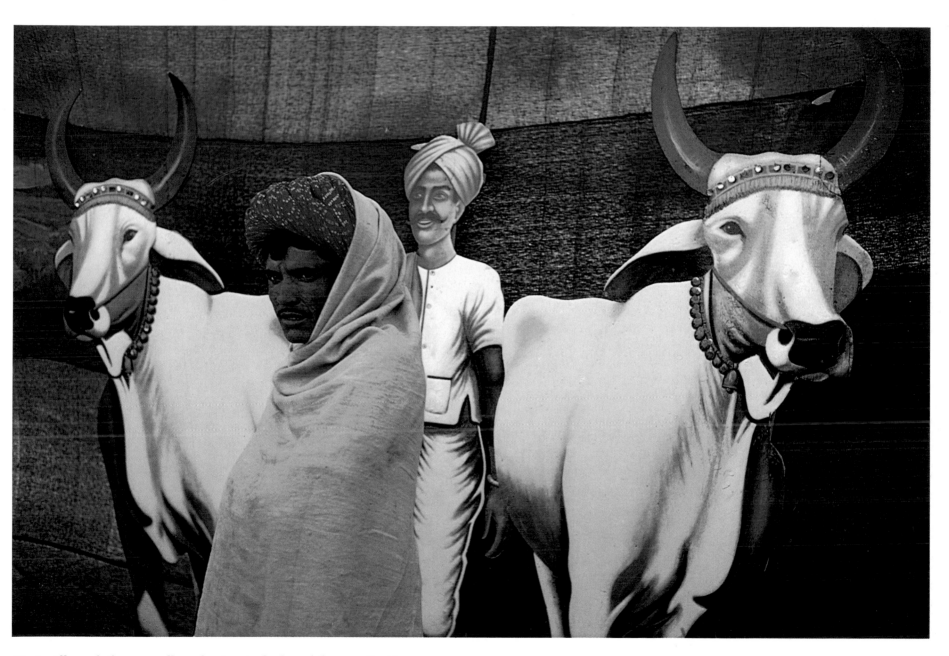

25 *A villager before a cardboard cut-out of a happy farmer, Pushkar.*

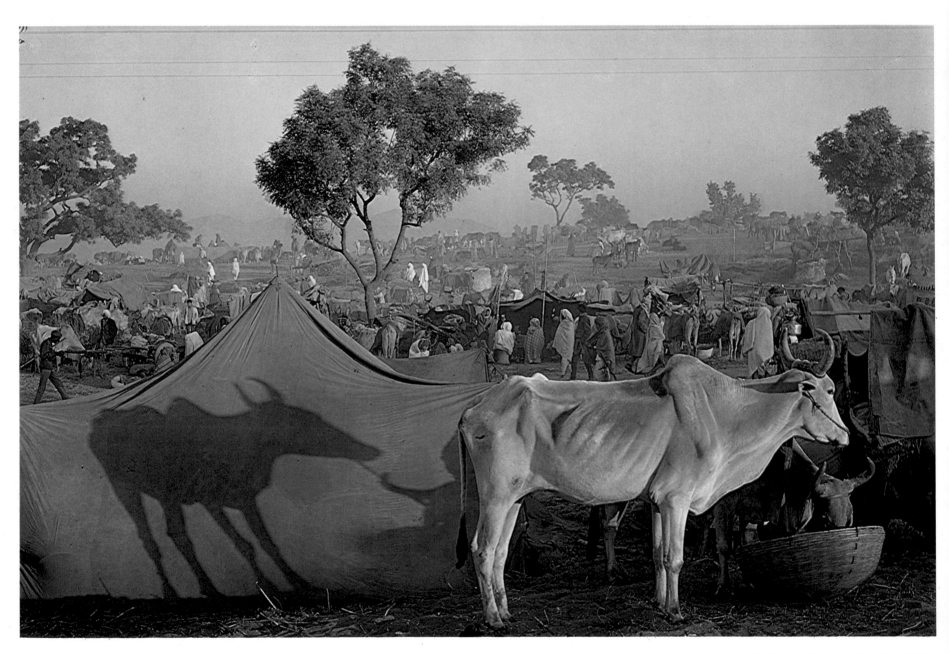

26 *Bullocks for sale, Pushkar Fair*

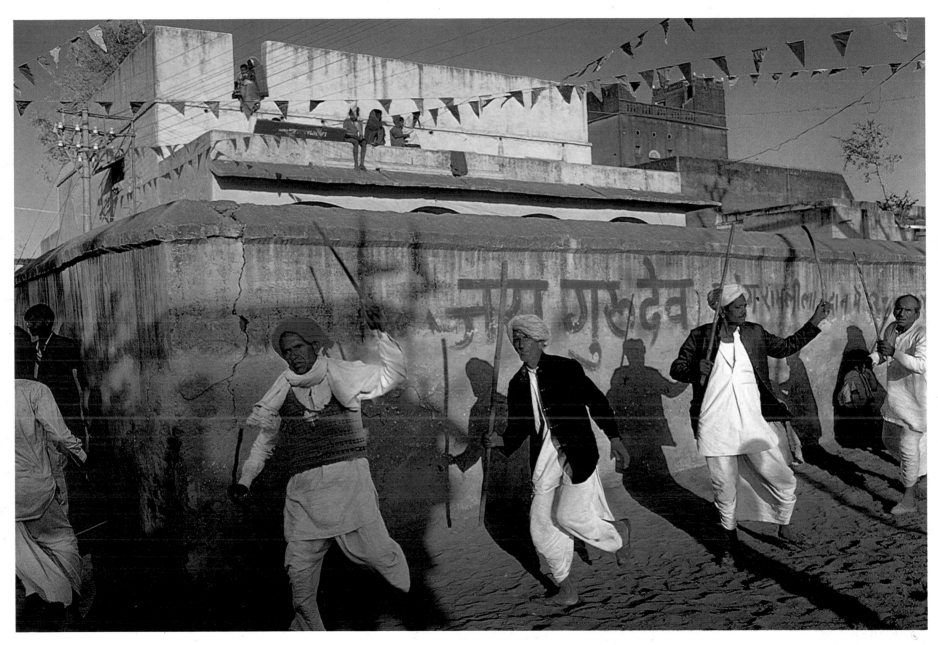

27 *Villagers of Laxmangarh celebrate Holi, the spring festival.*

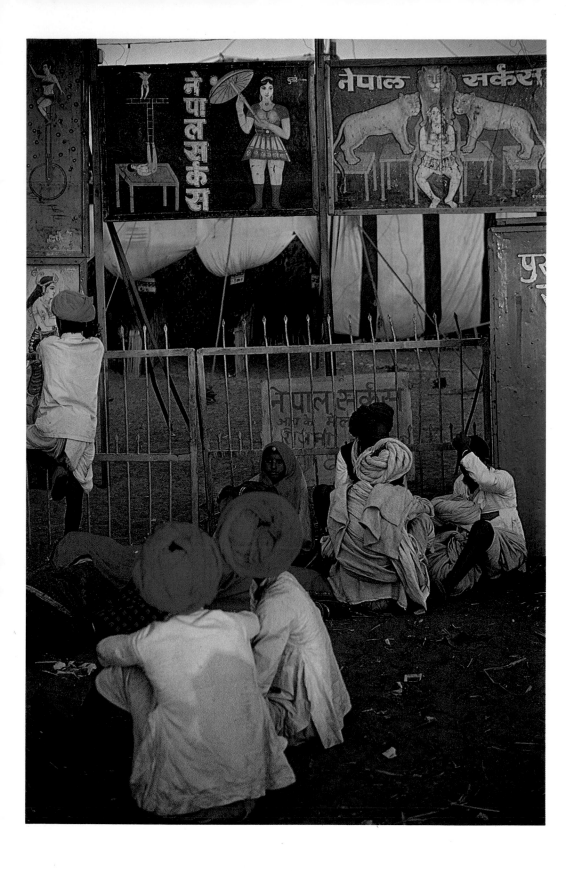

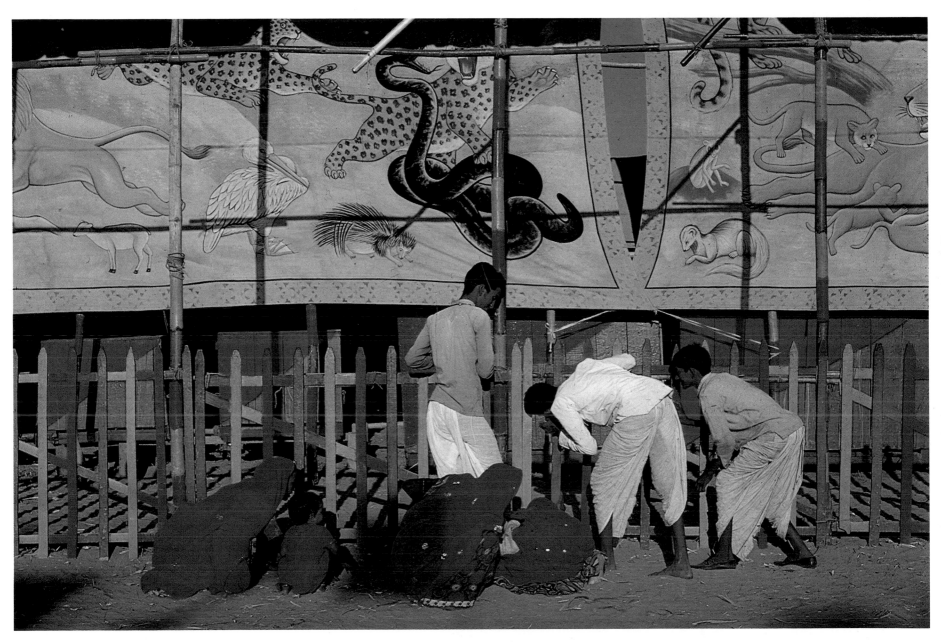

28/29 *Curious villagers outside a circus, Pushkar.*

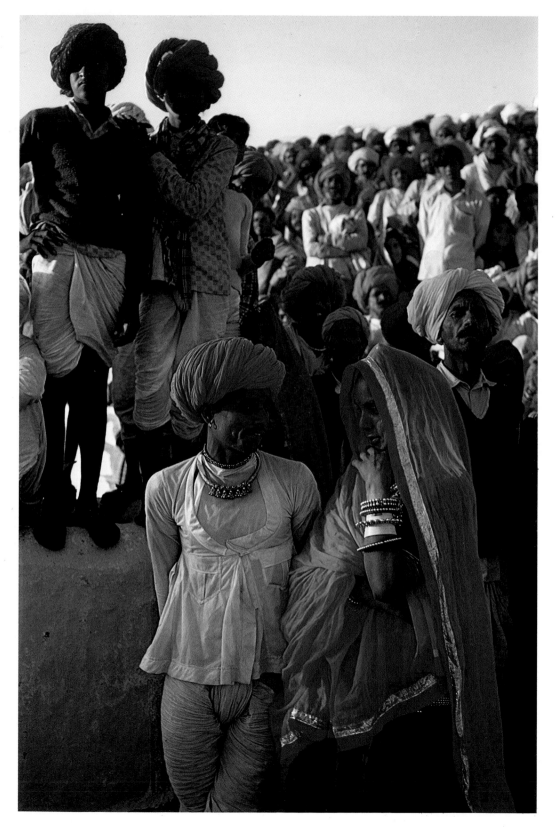

30/31 *Villagers at the Pushkar Fair.*

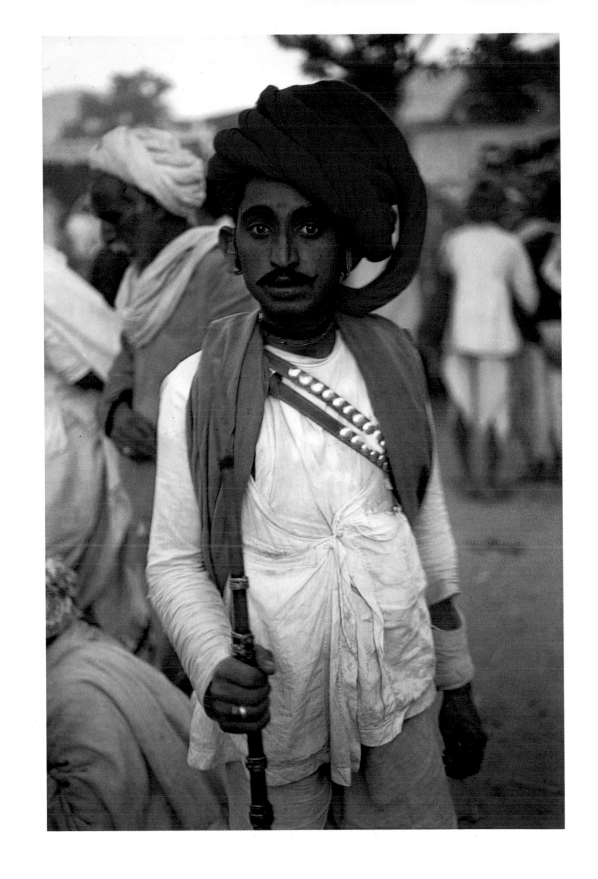

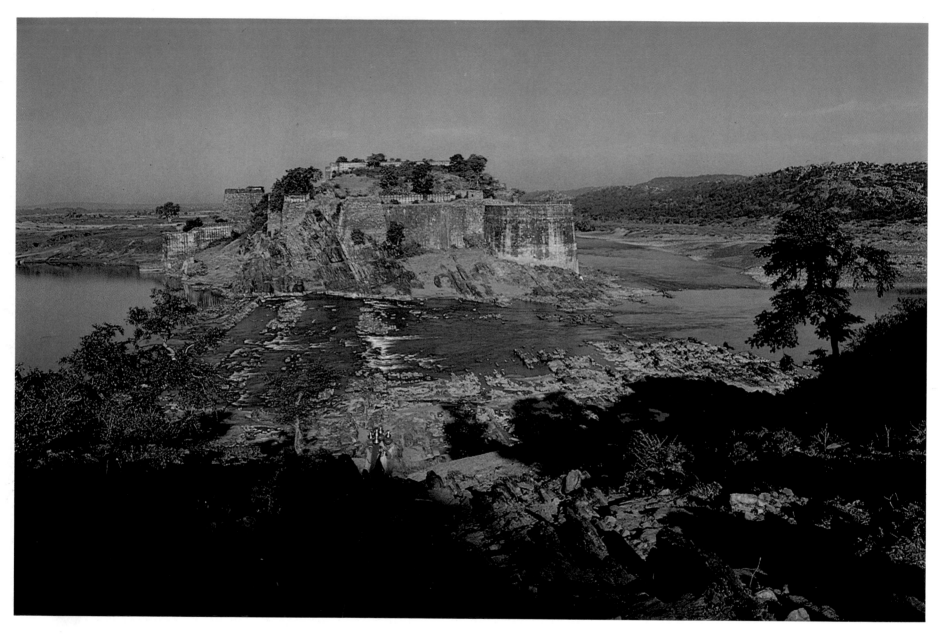

32 *The 12th-century Gagron Fort, near Jhalawar.*

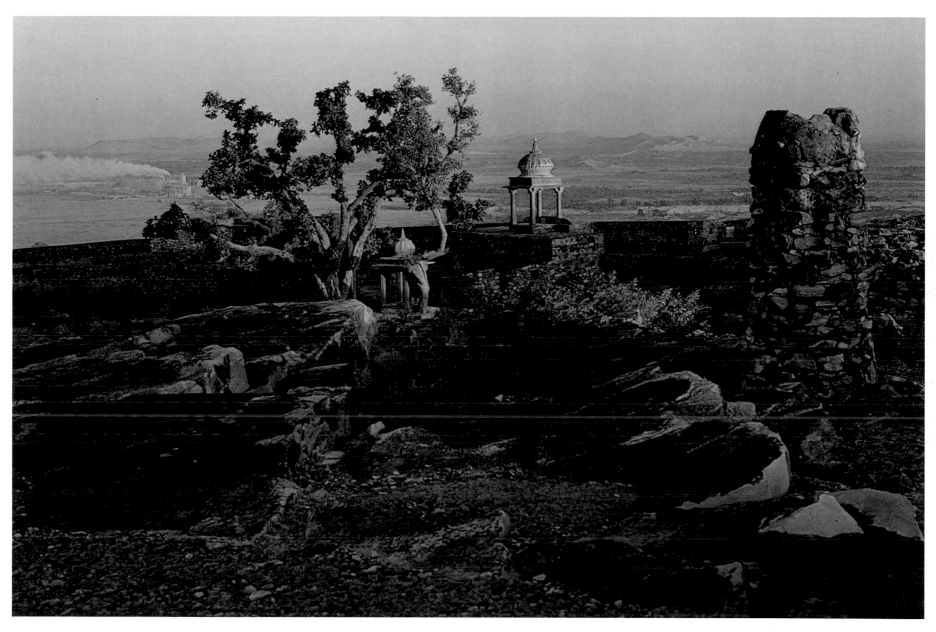

33 *A corner of Chittor Fort, Mewar.*

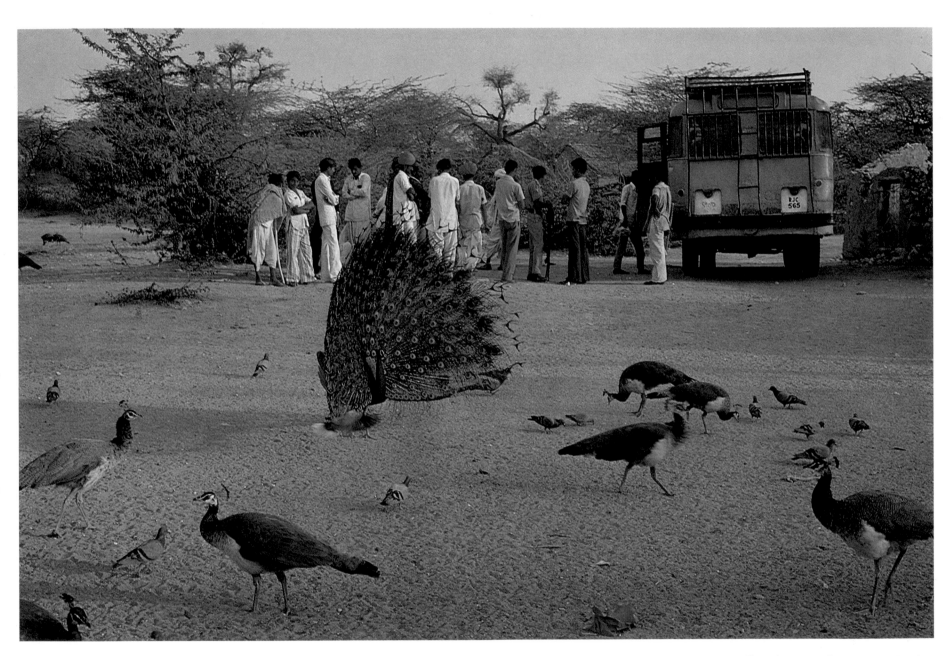

34 *A village bus stand, Barmer District.*

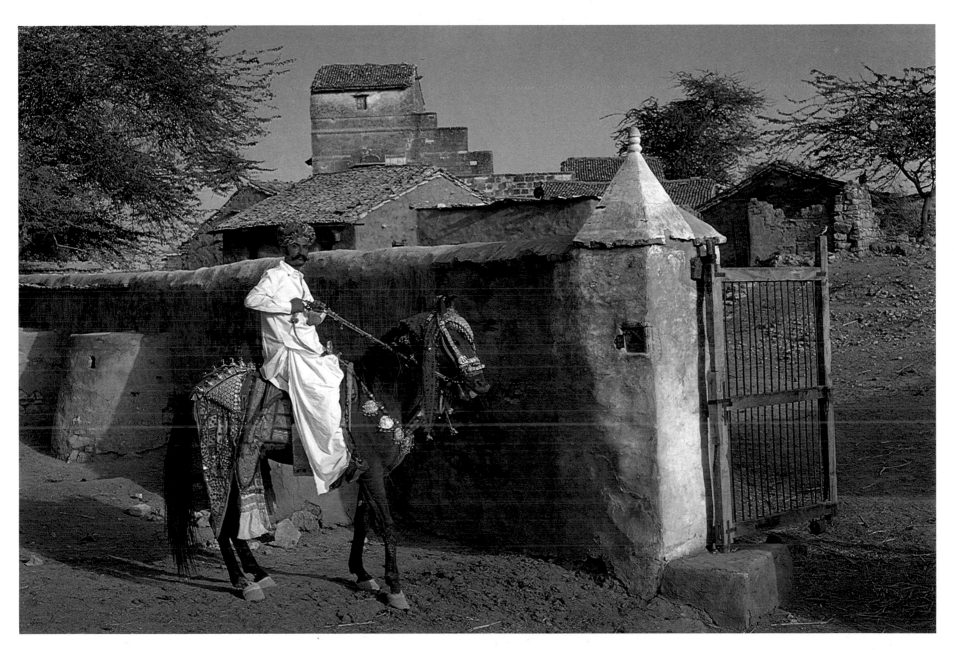

35 *A Rajput farmer and horsebreeder, Barmer District.*

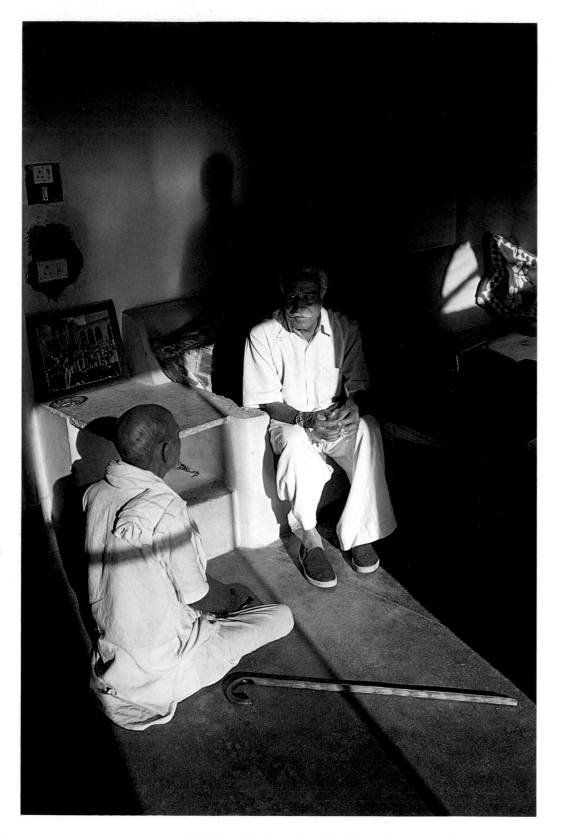

36 *Rajput landowner with visitor, Sawai Madhopur District.*

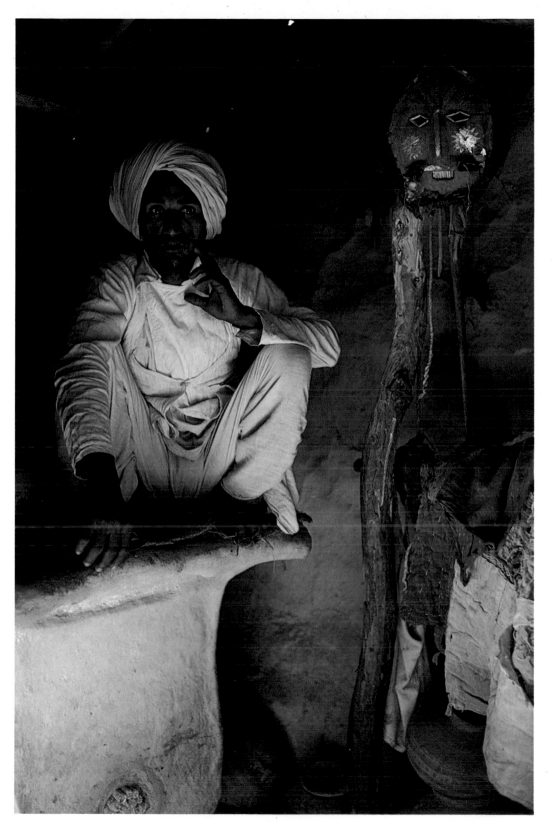

37 *A Bhil tribal, the mask is used in festivities honouring Gauri.*

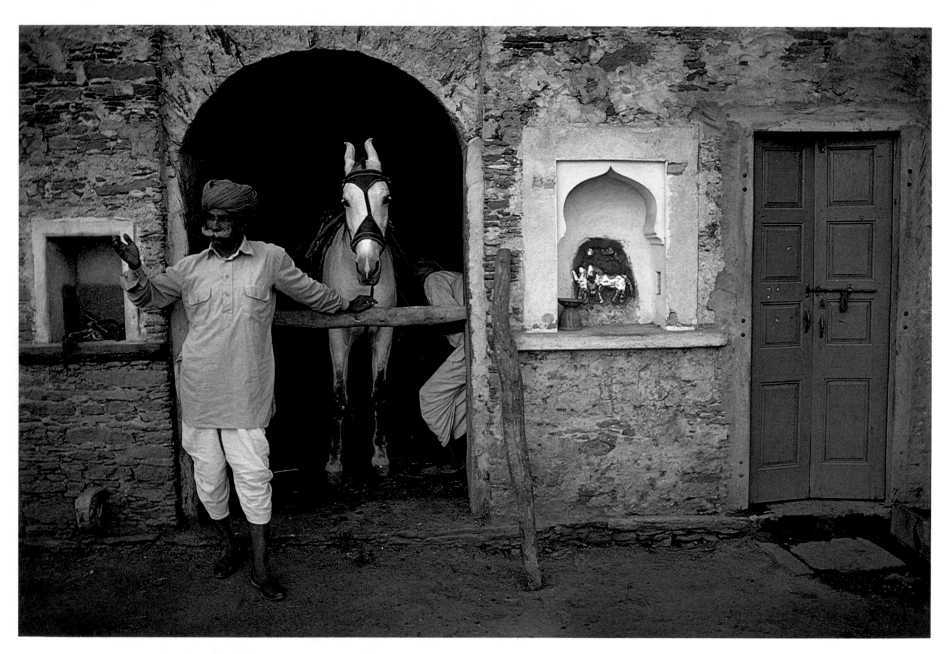

38 *A Rajput farmer; Revatji, the horse deity sculpted outside the stables, Mewar.*

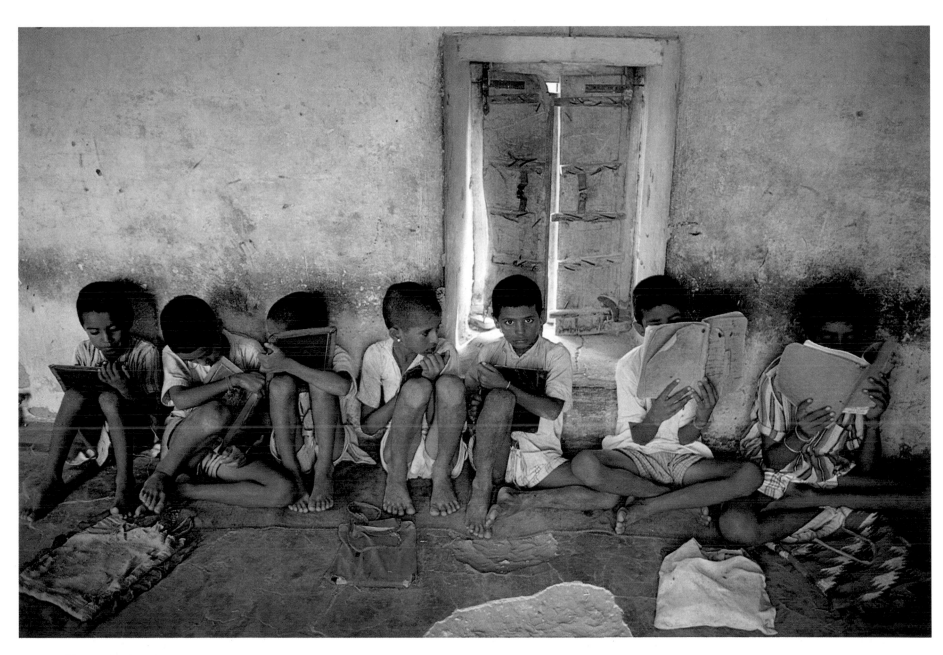

39 *A village school, Bikaner District.*

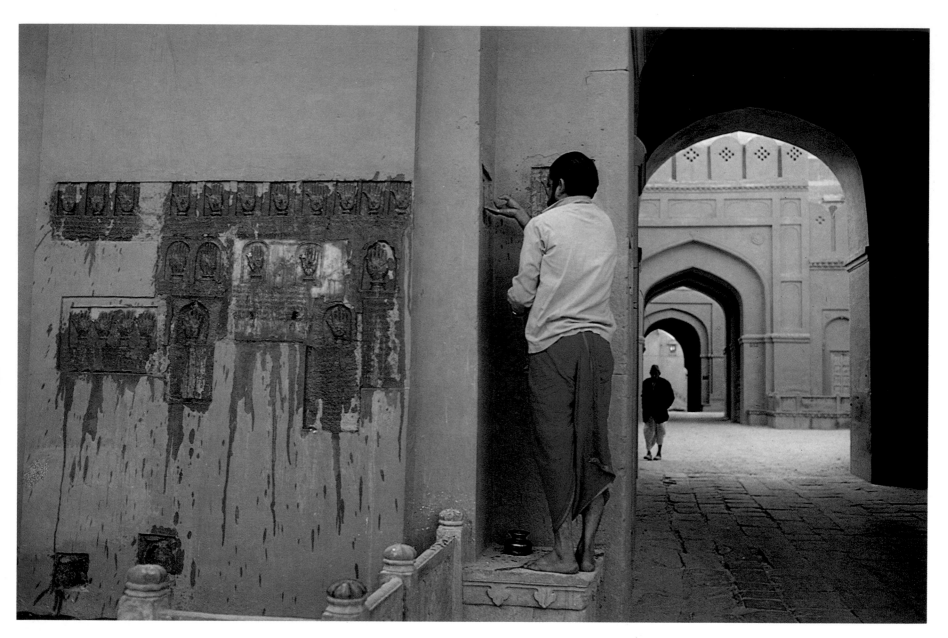

40 *A priest performs* puja; *handprints symbolize women who immolated themselves to become* sati, *Bikaner Fort.*

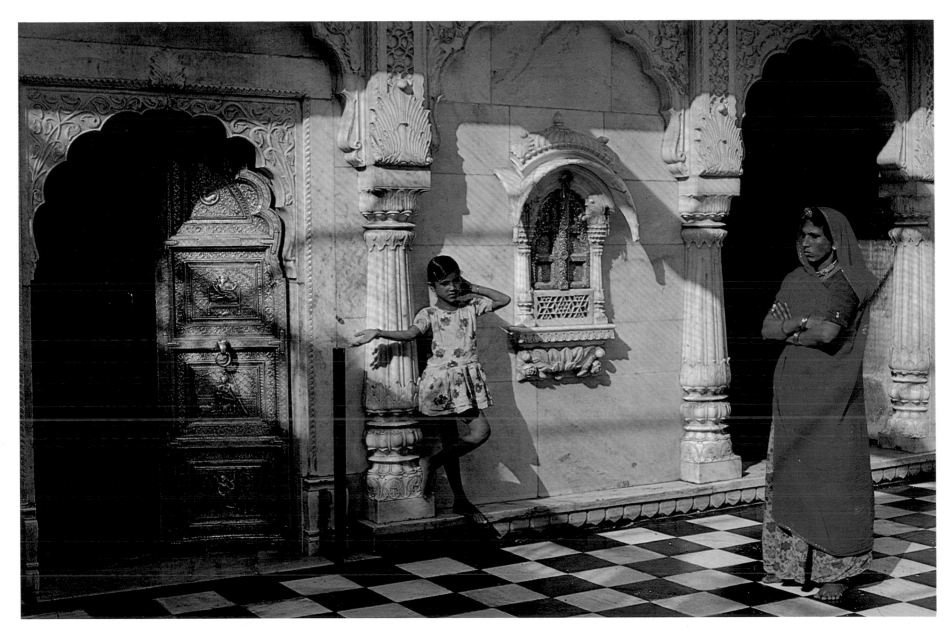

41 *At Deshnoke, the temple to Karni Mata, the popular deity of the Bikaner area.*

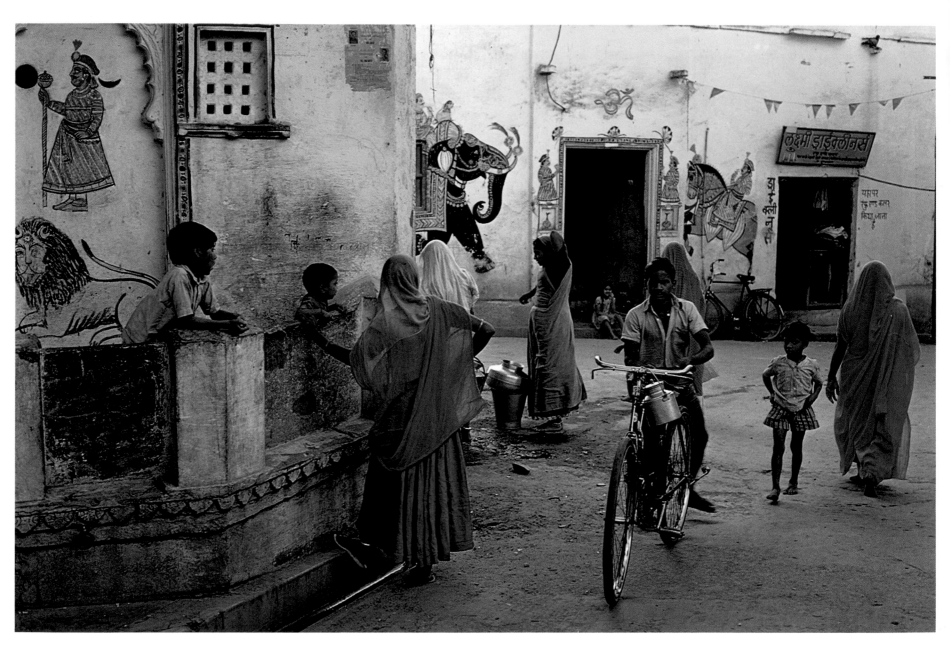

42 *Martial murals and a community well, Udaipur.*

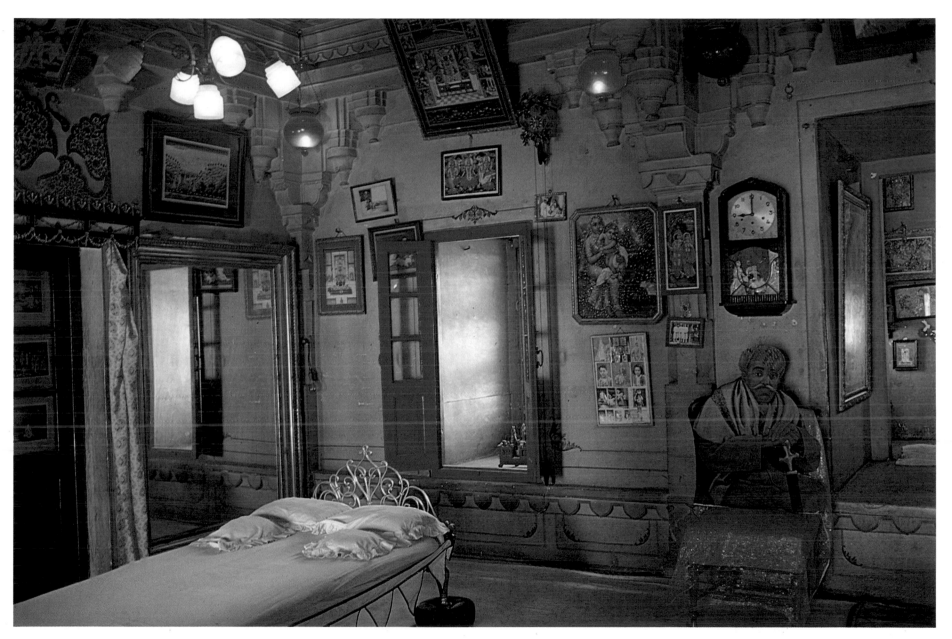

43 *A former Maharani's bedroom, the City Palace Museum, Udaipur.*

44 *Dr. Karni Singh, ex-Maharaja of Bikaner before his Lalgarh Palace.*

45 *A princely wedding, Bikaner.*

46 *The erstwhile Maharani and Yuvrani of Kotah, at a wedding, Bikaner.*

47 *Allah Jilai Bai, the court singer, entertains wedding guests.*

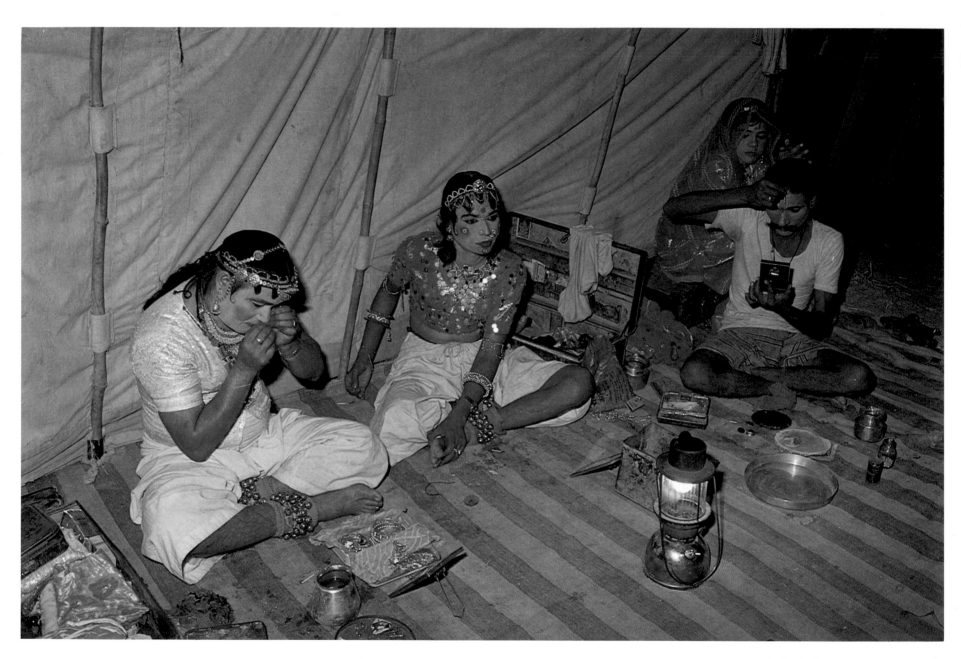

48 Folk theatre actors, Tilwara.

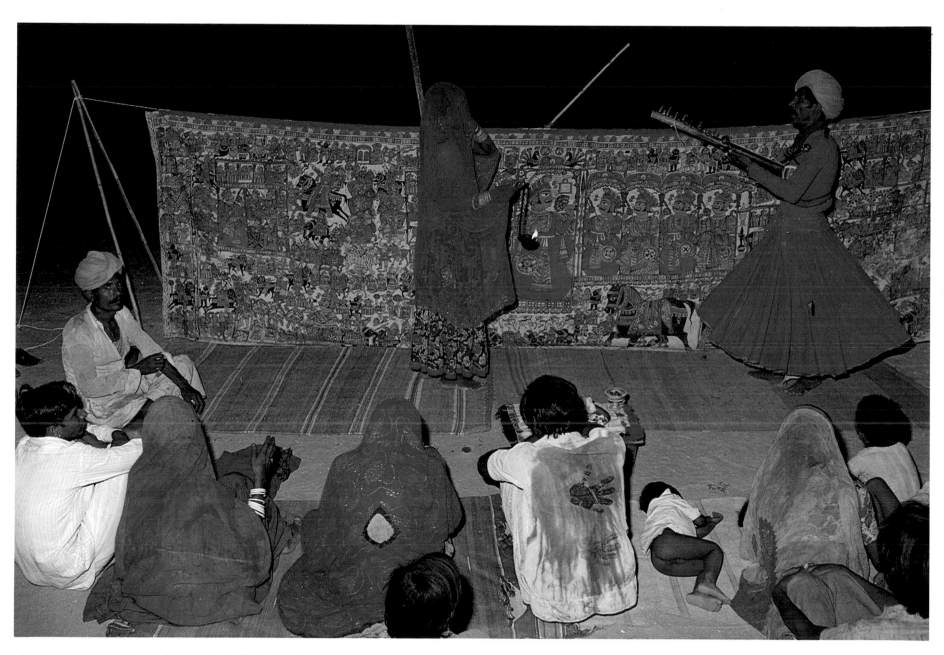

49 *A minstrel and his wife sing the ballad of Pabuji, the folk hero, pictured on the scroll, Jodhpur.*

50 Centennial celebrations, Mayo College, Ajmer.

51 *Holi, the spring festival, Laxmangarh, Shekawati.*

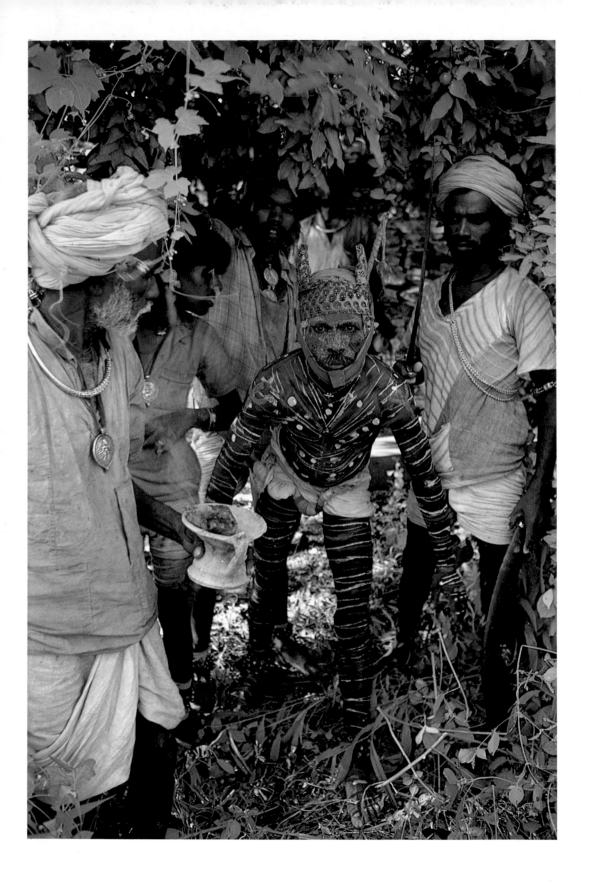

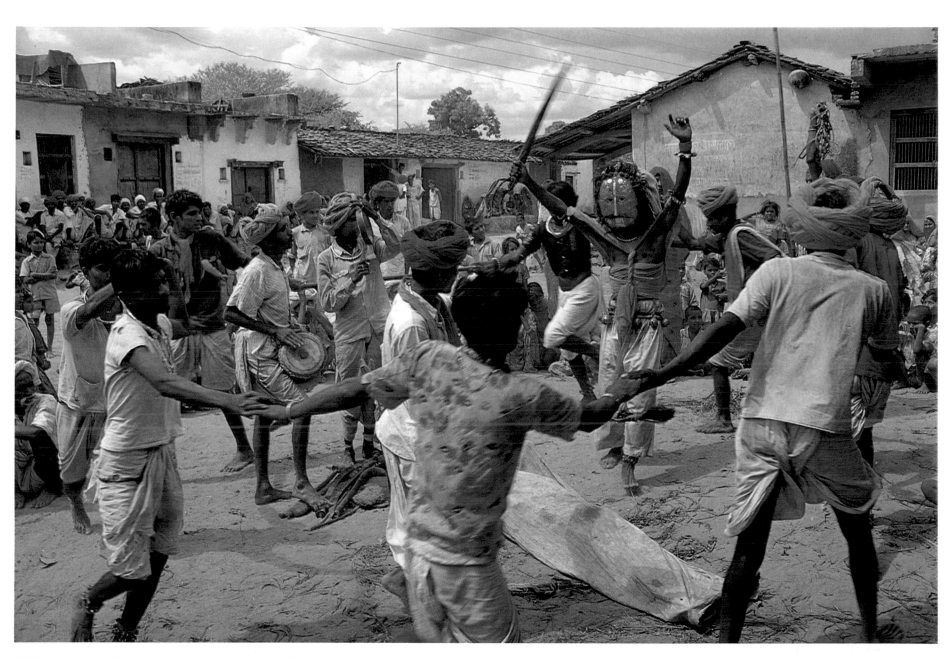

52/53 (Left) A Bhil tribal made up as a tiger, (right) to participate in the dance-drama
honouring Gauri, the goddess of abundance, Mewar.

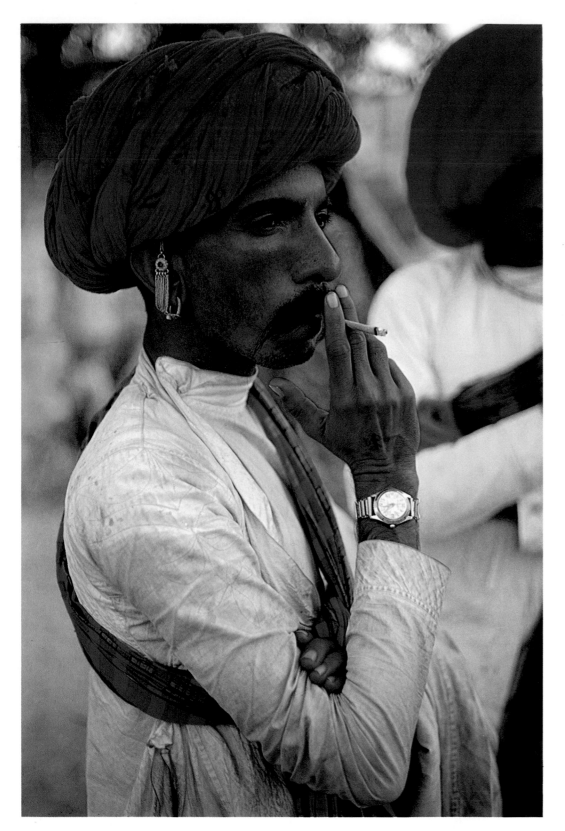

54 *A Gujar villager, Pushkar.*

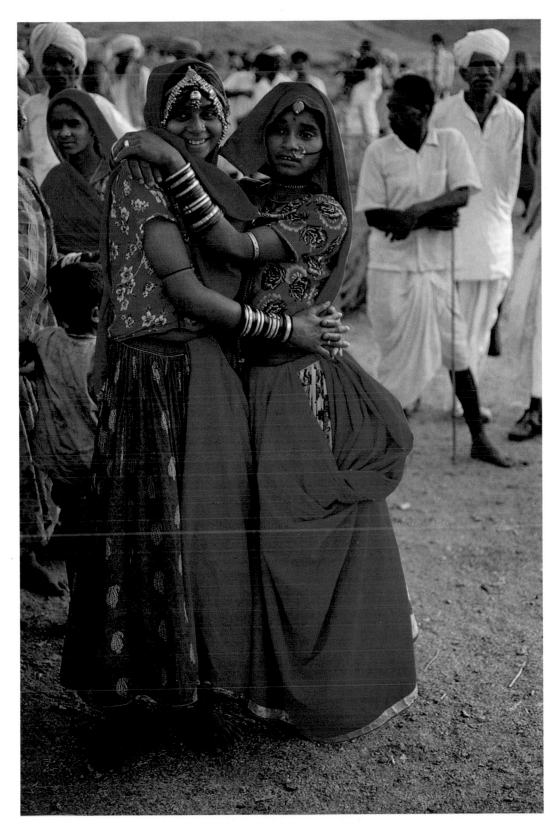

55 *Bhil women embrace, Rakhab Dev, Mewar.*

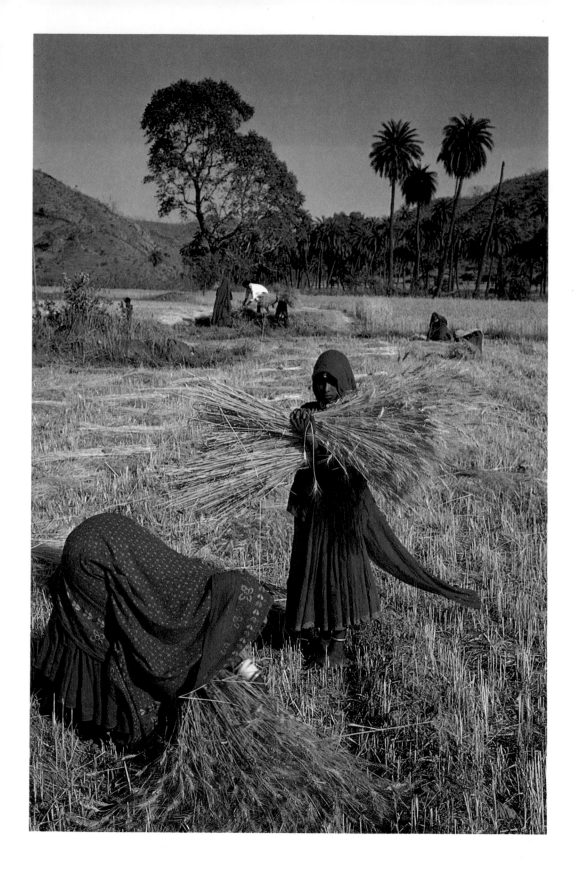

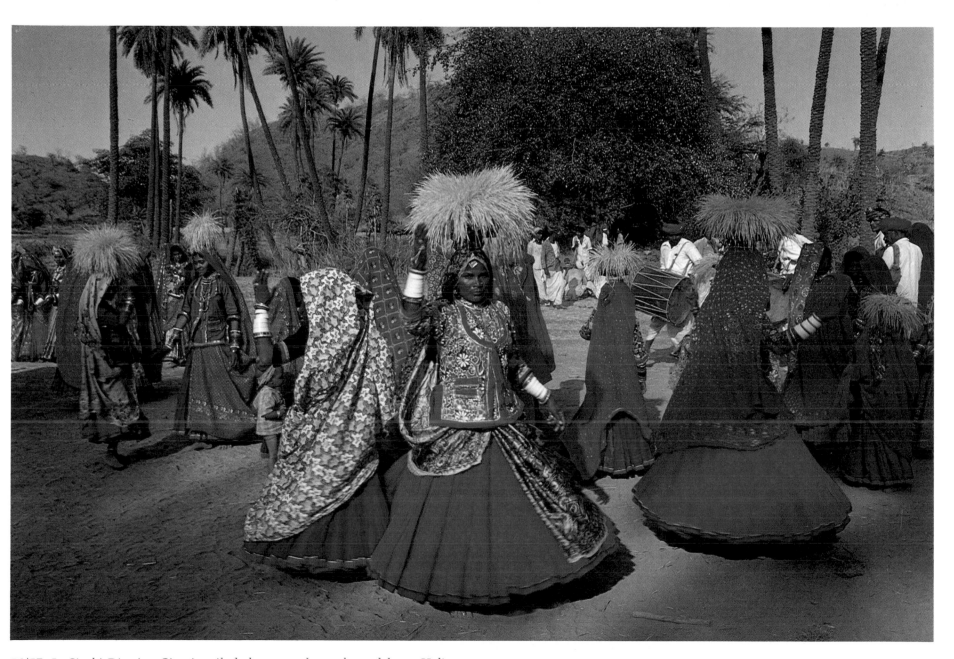

56/57 *In Sirohi District, Girasia tribals harvest wheat, then celebrate Holi.*

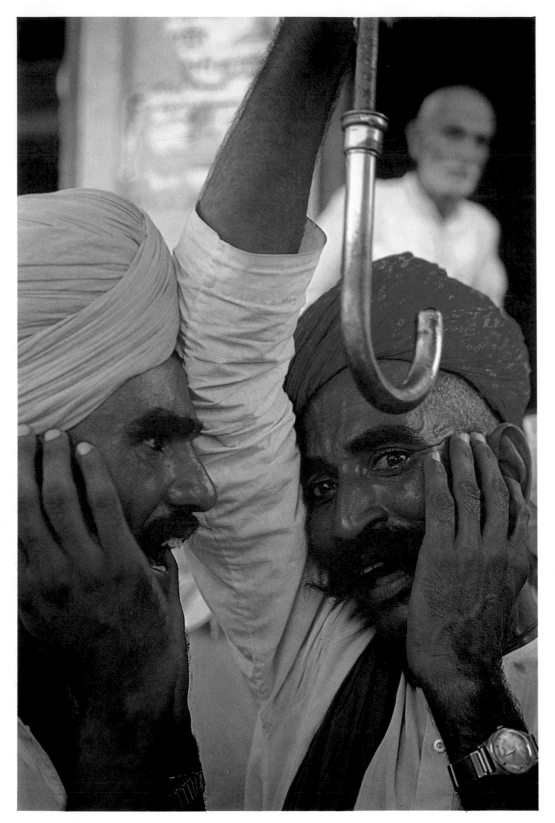

58 *Villagers of Merta sing during the monsoon.*

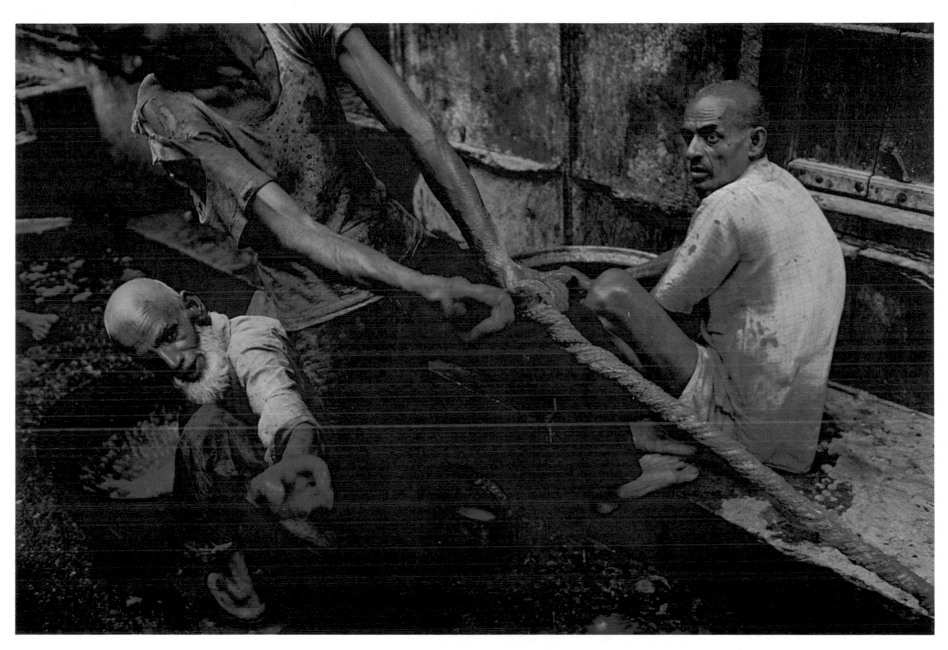

59 *Cloth being dyed in a Jaipur street.*

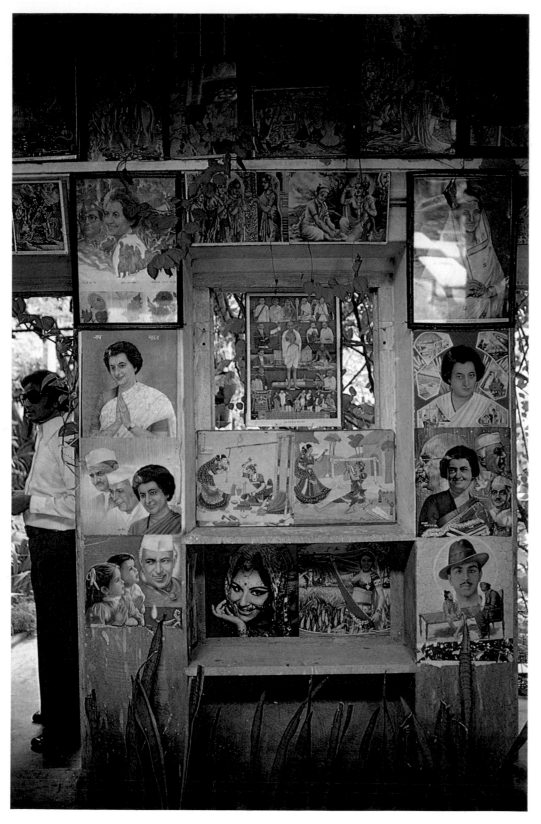

60 *Lithographs of gods, politicians and movie stars decorate a tea shop, Jaipur.*

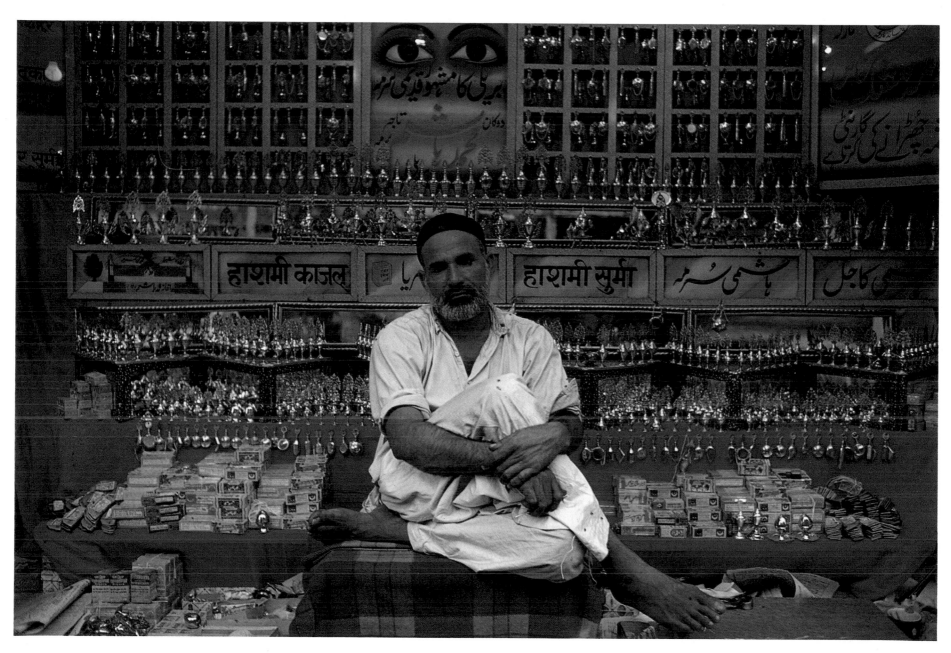

61 *A shopkeeper selling cosmetics, Ajmer.*

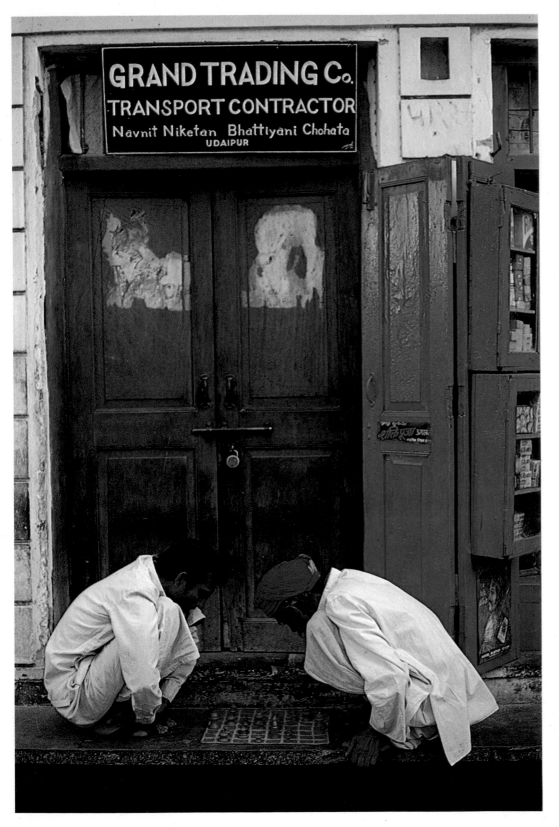

62 Chess players, Udaipur.

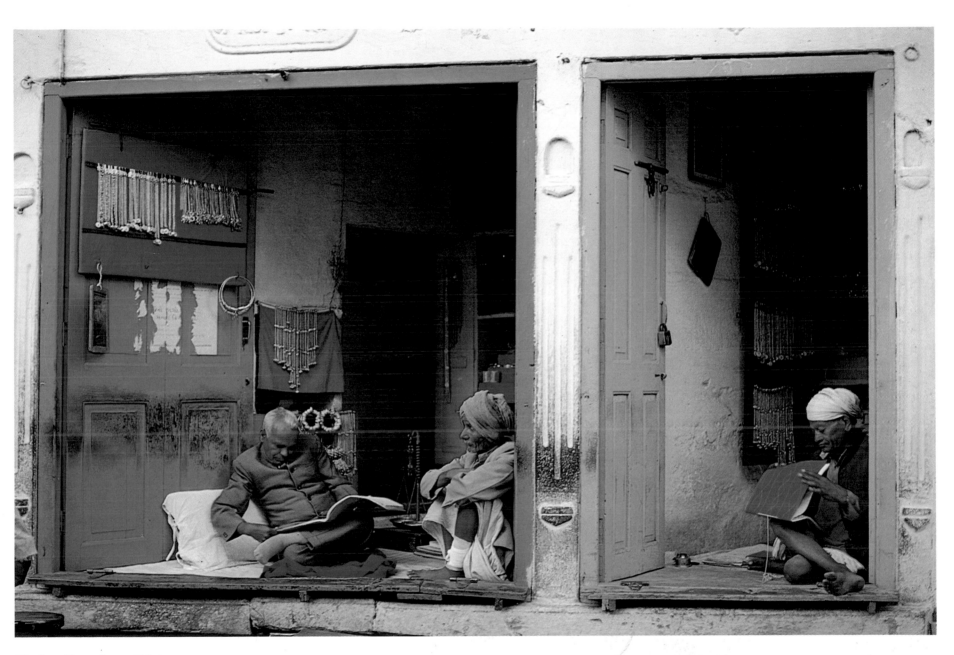

63 *Jewellery shops, Udaipur.*

64 A tailor with puppets and the sculpted image of a folk hero, Udaipur.

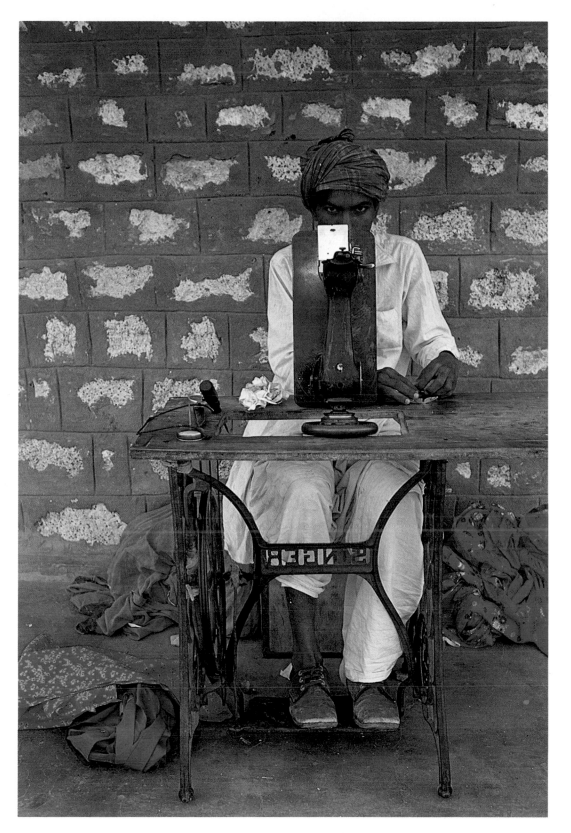

65 *A village tailor, Barmer District.*

66 *Women pound grain in a village near Osian, Marwar.*

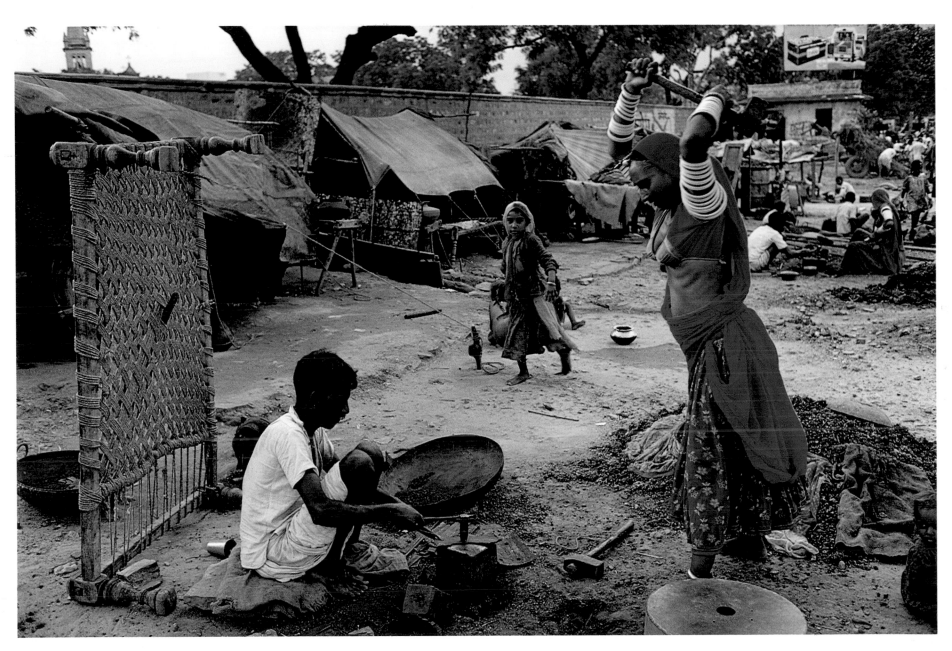

67 Gaudilia Lohars, *the nomads and ironsmiths, Ajmer.*

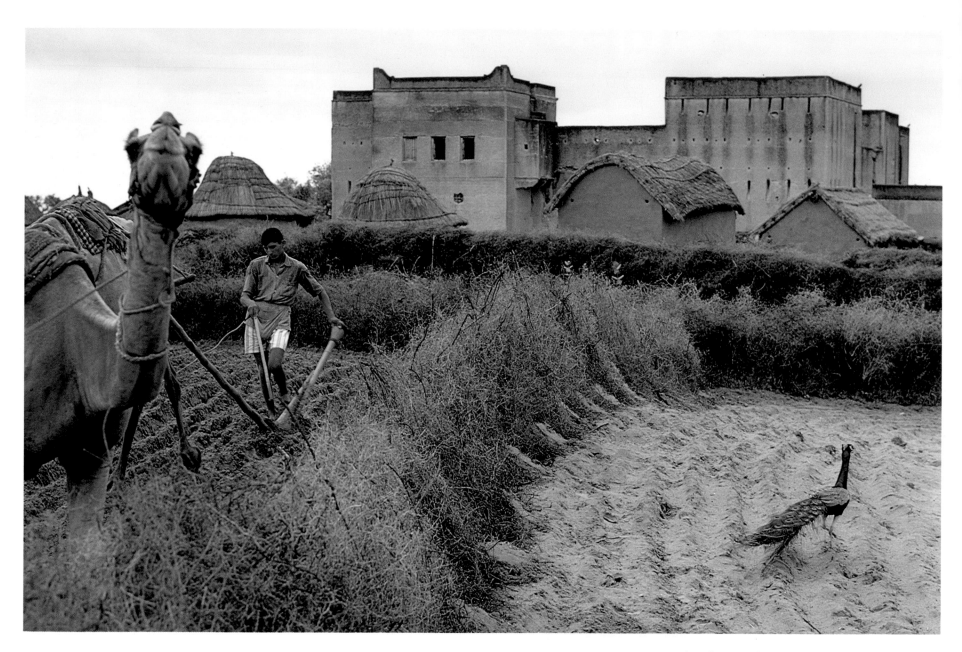

68 *Ploughing with the aid of a camel, Shekawati.*

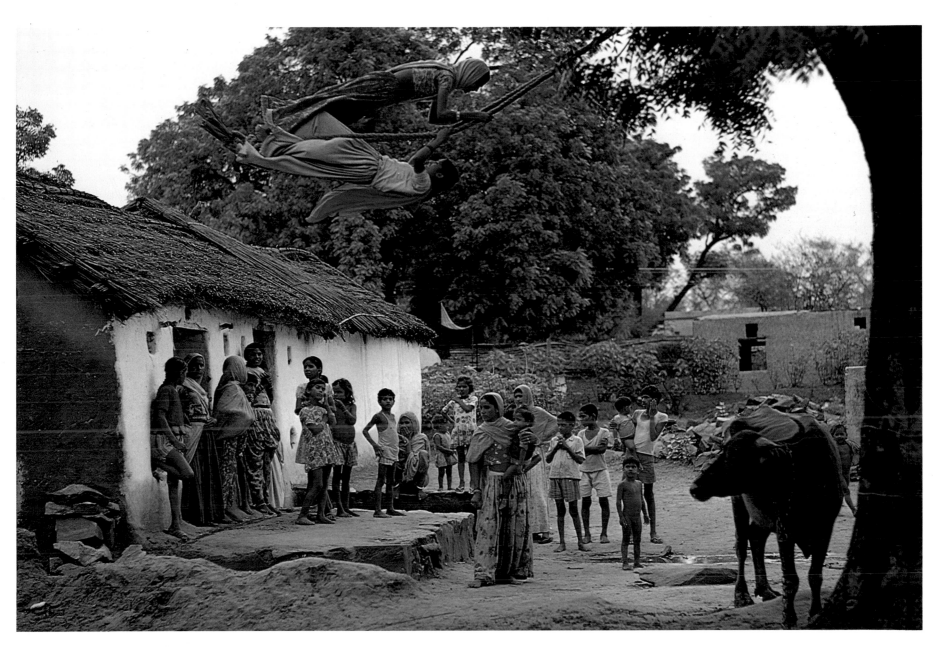

69 *Monsoon swings in a village near Jaipur.*

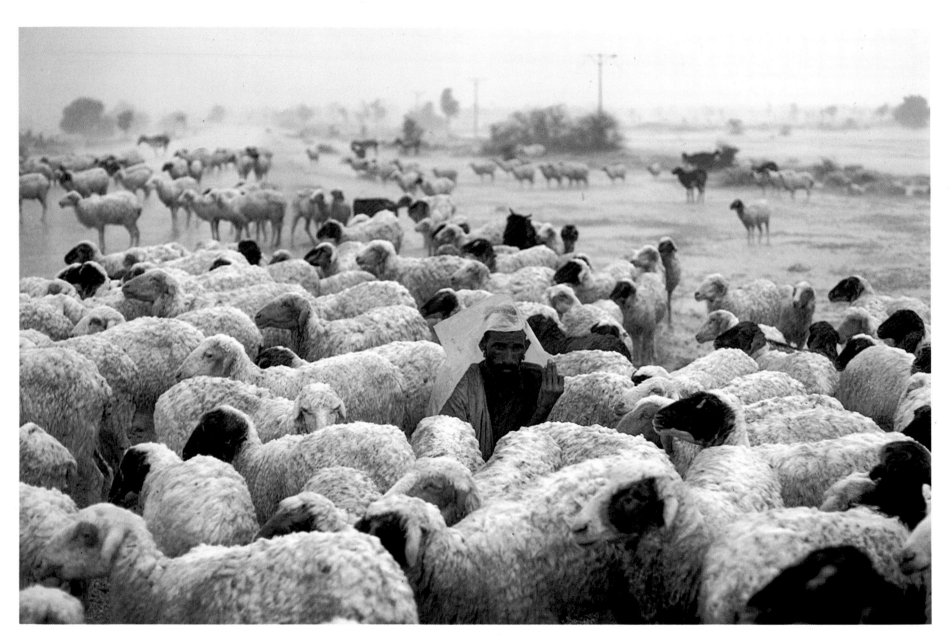

70 *A sheep herder caught in a shower in the Thar Desert.*

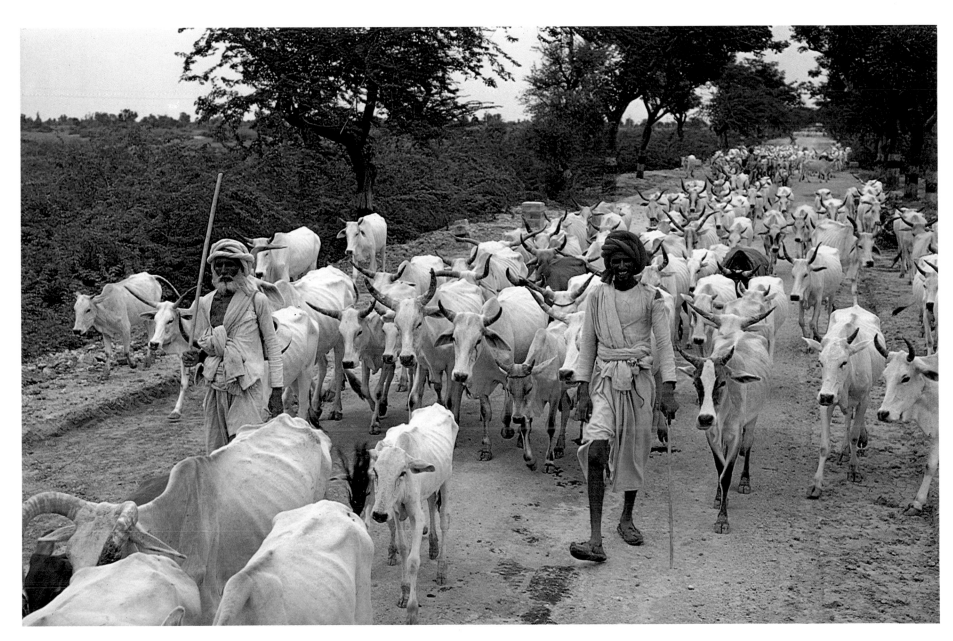

71 *Villagers bring livestock home after the summer grazing, Pali.*

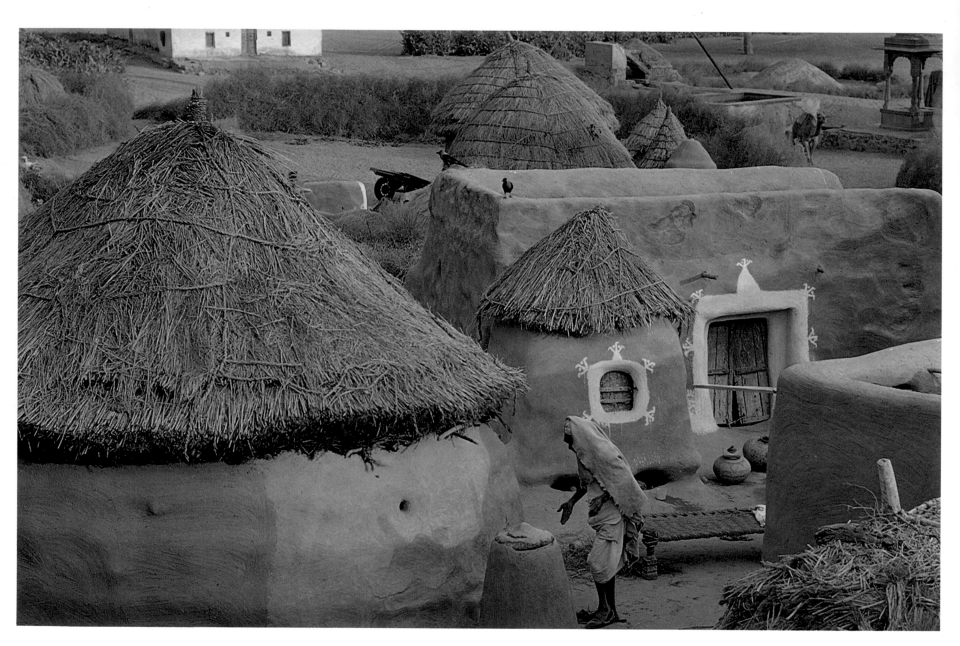

72 *A village, Bikaner District.*

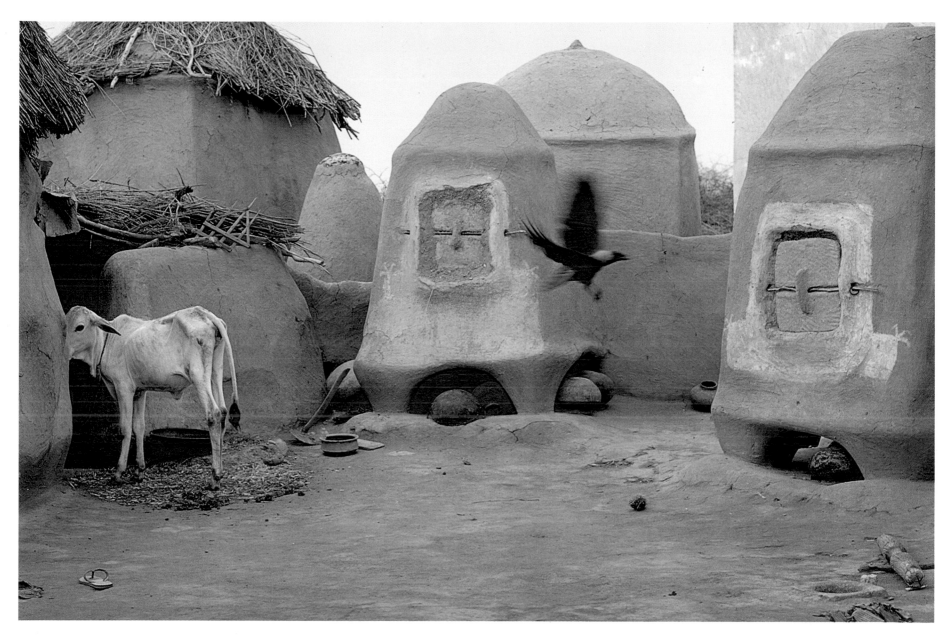

73 *A calf, a crow and storage bins, Bikaner District.*

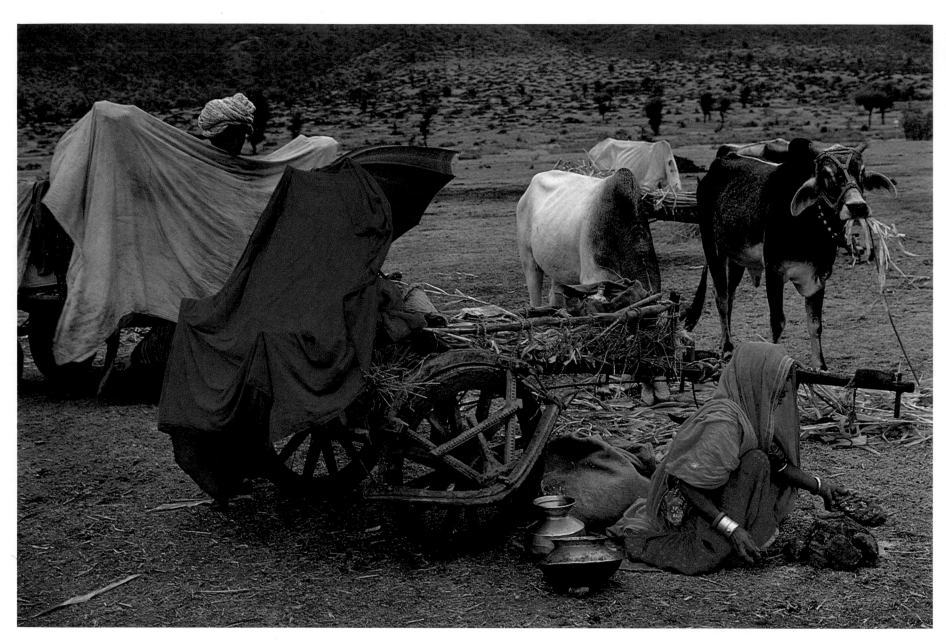

74 *Villagers dry themselves after a winter shower, Sawai Madhopur District.*

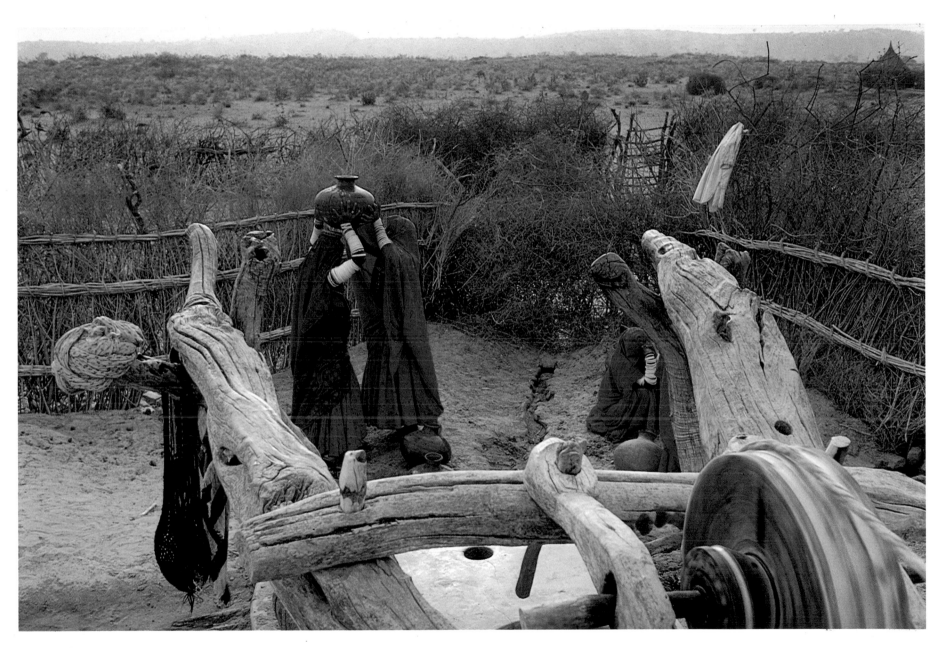

75 *A village well, Barmer District.*

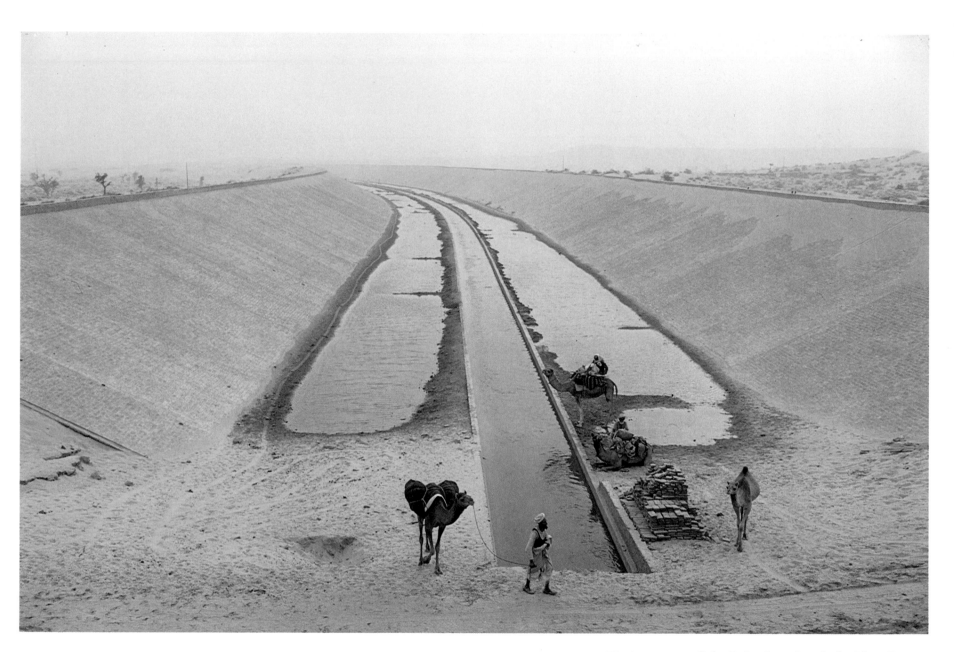

76 *A segment of the Rajasthan Canal, the Thar Desert.*

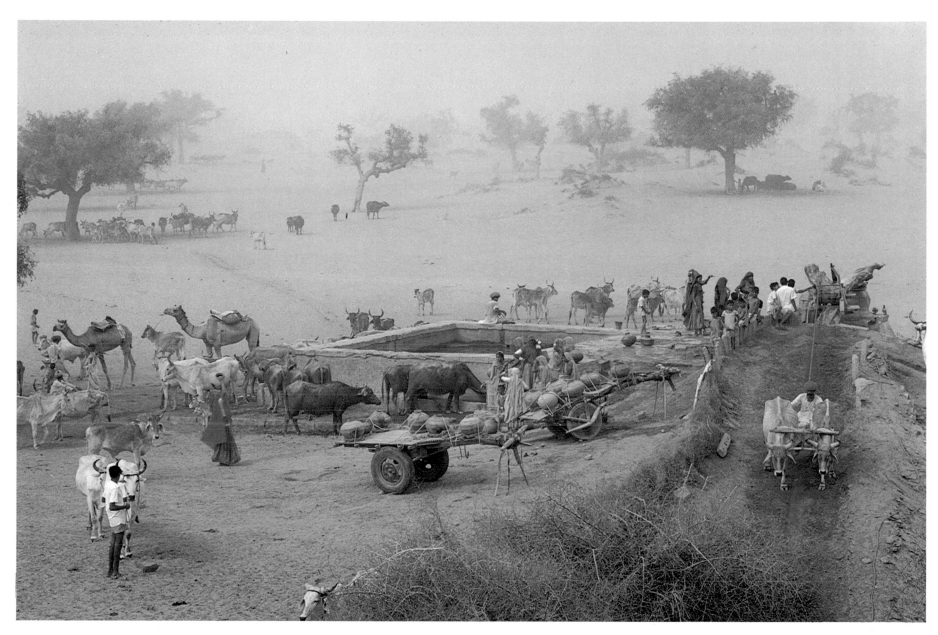

77 *A village well shrouded in dusty winds, Jodhpur District.*

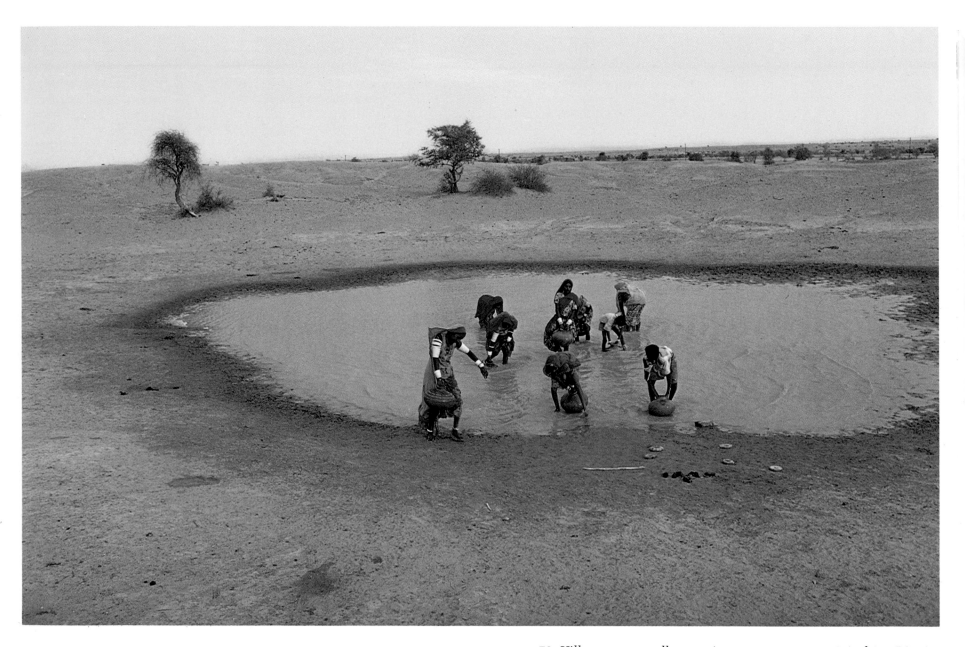

78 *Village women collect precious monsoon water, Jaisalmer District.*

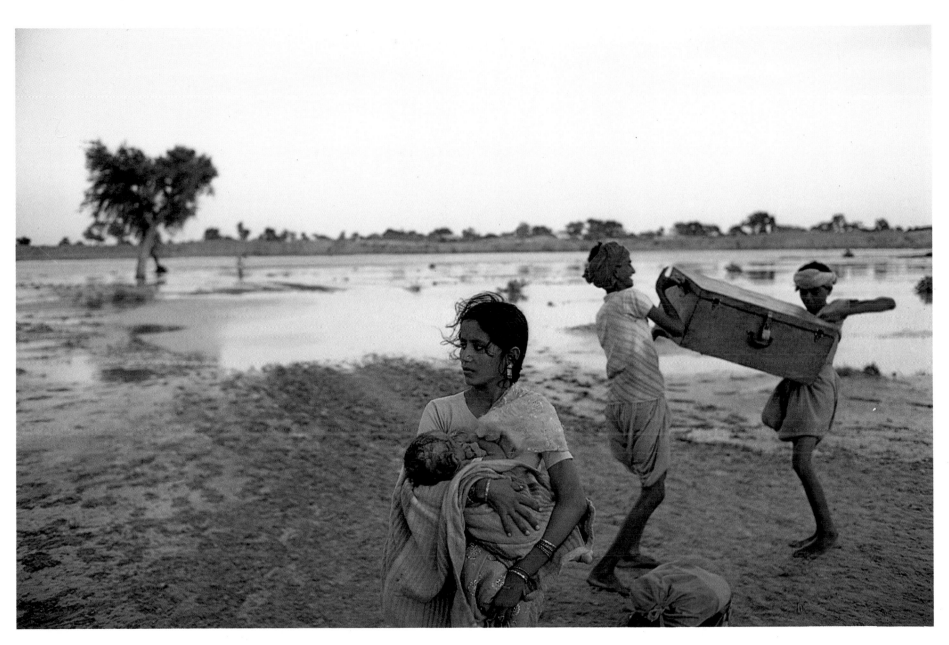

79 *A family who waded through the flooded Luni river.*

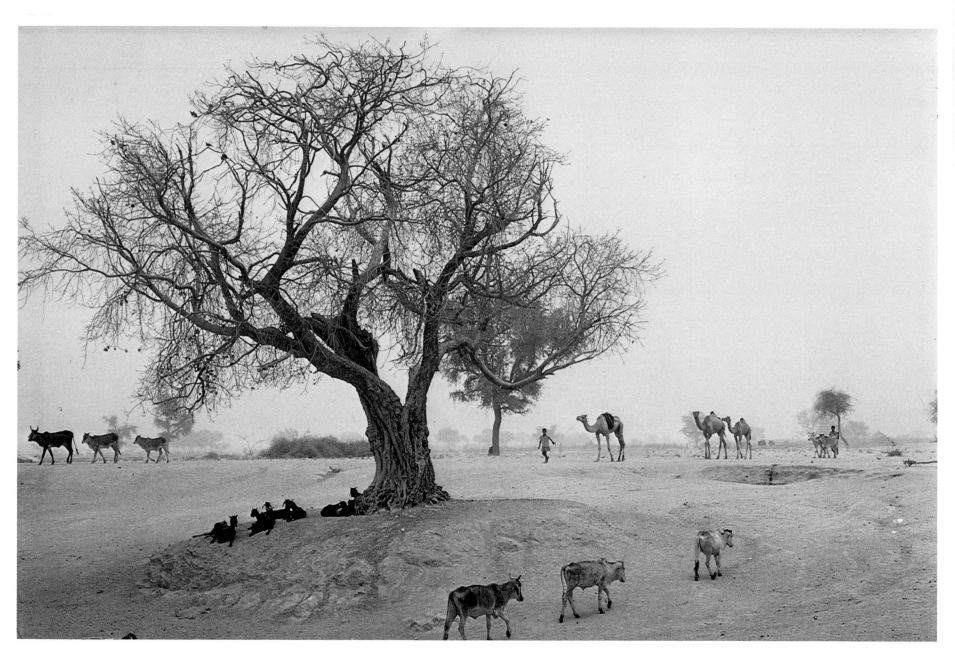

80 A tree, cattle and camels in the summer drought, Barmer District.